ZEN DOGS

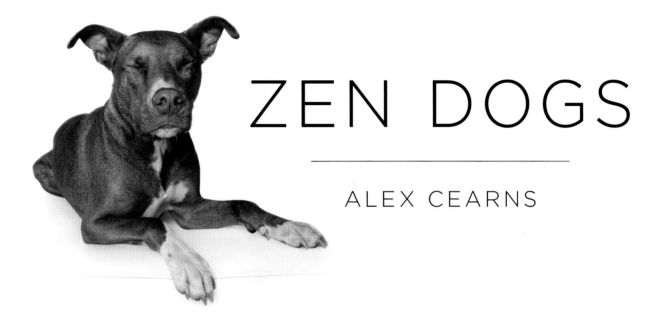

ZEN DOGS

ALEX CEARNS

HarperOne
An Imprint of HarperCollinsPublishers

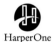

HarperCollins books may be purchased for educational, business, or sales promotional use. For information please e-mail the Special Markets Department at SPsales@harpercollins.com.

HarperCollins website: http://www.harpercollins.com

FIRST EDITION

Designed by Terry McGrath

ISBN 978-0-06-245937-4

17 18 19 20 SCP 10 9 8 7 6 5 4 3 2

To the dogs of the world. We can learn so much from you when we have open minds and hearts.

CONTENTS

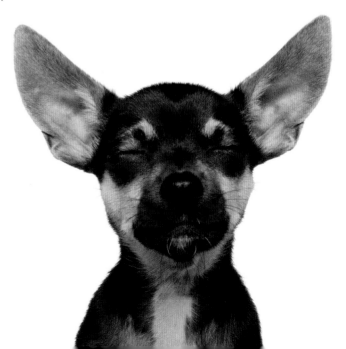

INTRODUCTION

As a pet and wildlife photographer, my job is my lifestyle and my world is all about animals. I love every creature I meet, but dogs are my absolute favorite. Throughout my life, dogs have been great friends and cherished family members. Every day I'm inspired by their boundless ability to fill the world with joy and unconditional love. Their incredible generosity, responsiveness, and sense of fun make them ideal to photograph.

I've had just about every kind of dog in my studio, each endlessly expressive and utterly unique. A few years ago, I captured a particularly compelling moment with a most gorgeous shar-pei, Suzi. Her closed eyes and wide, contented smile suggested calm, euphoric bliss. I called the image *Zen Dog,* and her humans were delighted with the shot.

That photo of Suzi inspired me to capture Zen moments with other dogs. I looked for an expression of spontaneous canine bliss: eyes gently closed, body relaxed, and spirit totally carefree. I discovered that the blink happens in a split second, but truly Zen-worthy expressions happen only when my subject and I are in sync. In that moment nothing else matters. It's pure, unadulterated joy. I also discovered that, in that split second, the dog's distinctive personality—playful, placid, or confident—shines through.

As an animal lover, seeing blissful dogs always brings a smile to my face, and I know I'm not alone. It's even more poignant for me when I know my subject has come from a difficult background. I'm very passionate about animal rescue, and some of the dogs included here experienced hard times before finding their forever homes.

I feel very fortunate to have been united with my two rescue dogs, Pip and Pixel. Found wandering the streets as a twelve-week-old puppy, Pip was severely undernourished. With the help of GreyhoundAngels of Western Australia and a loving foster family, Pip regained her strength and stole my heart at first sight. Pixel was surrendered to Brightside Farm Sanctuary when she was a tiny greyhound puppy. She was a gift to me from the founder of the sanctuary—possibly the best gift I've ever received. Pixel has become a wonderful ambassador for greyhound rescue, appearing in magazines, books, and TV spots. Pip and Pixel even have their own Facebook page, Black Beetle, which has thousands of followers.

Every day my dogs help me to appreciate the simple things in life. Research has found that owning a dog can lower blood pressure, reduce stress hormones, and boost levels of feel-good chemicals in the brain, but every dog lover knows the benefits are far too many to list. I hope this series of images is a gentle and positive reminder of the peace, calm, and joy that dogs bring to our lives. Like the dogs in these photos and the canine companion on your couch, we all need to stop, take a break, relax, and unwind—to breathe it all in and be fully present in each and every experience.

—*Alex Cearns*

ZEN DOGS

Tension is who you think you should be.
Relaxation is who you are.

—CHINESE PROVERB

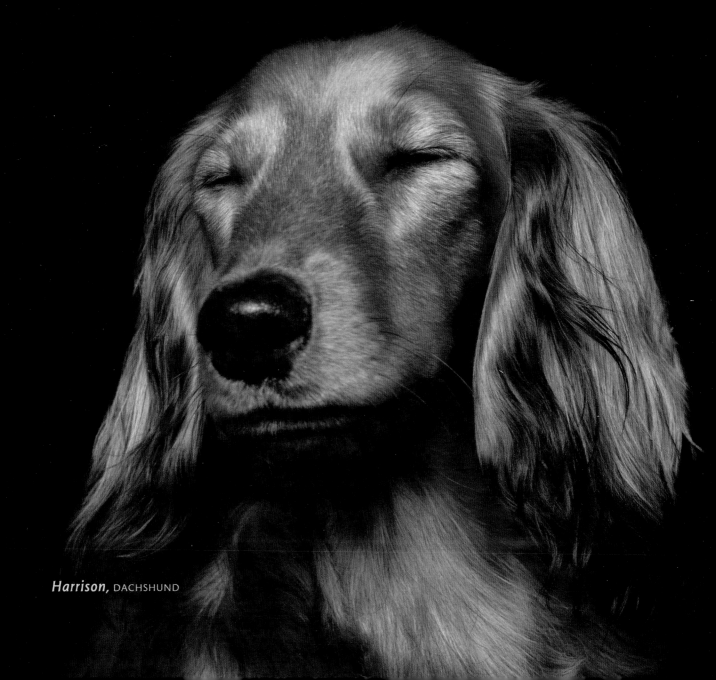

Harrison, DACHSHUND

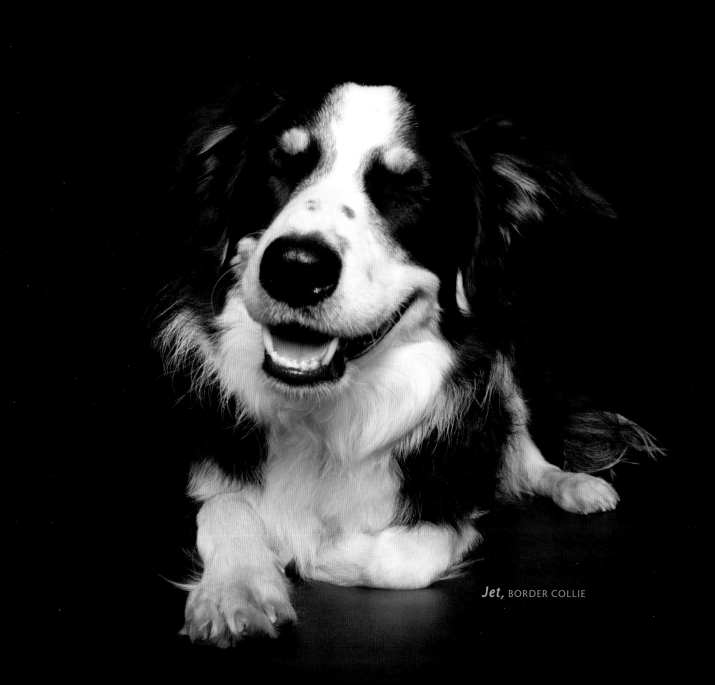

Jet, BORDER COLLIE

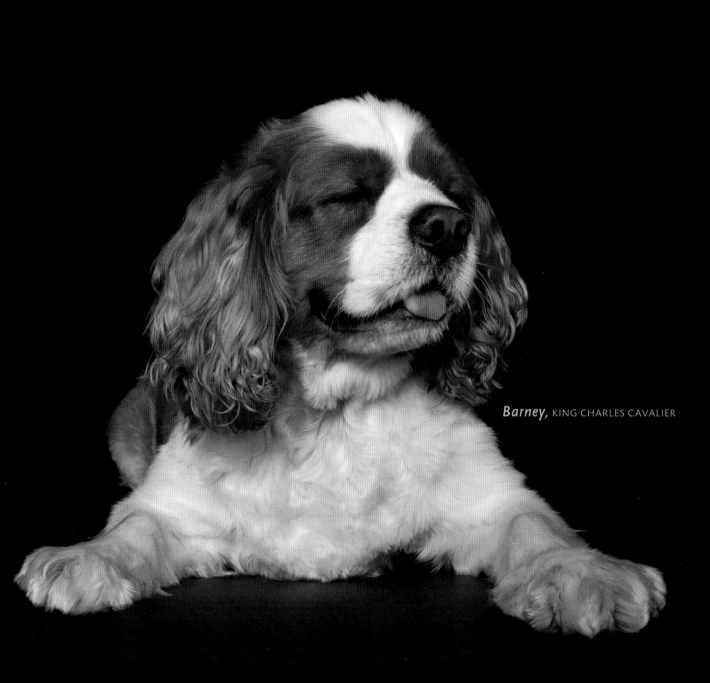

Barney, KING CHARLES CAVALIER

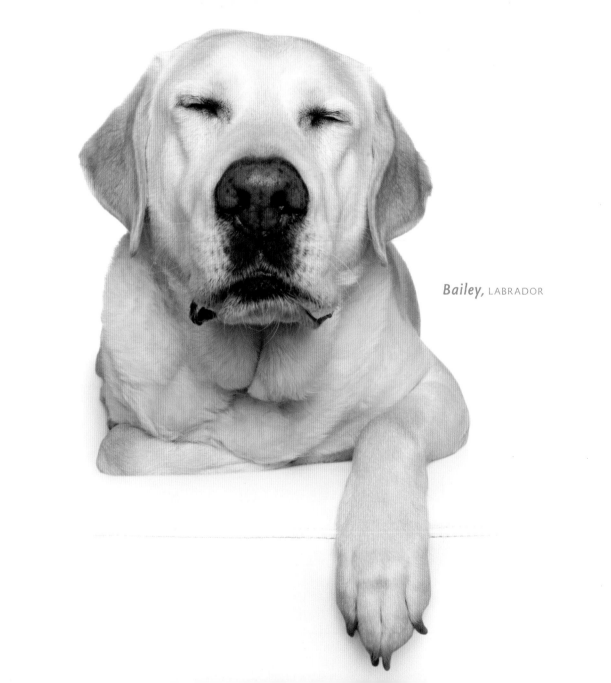

Bailey, LABRADOR

Kono, MINIATURE POODLE

Very little is needed to make a happy life.

—MARCUS AURELIUS

Kato, AMERICAN STAFFORDSHIRE TERRIER

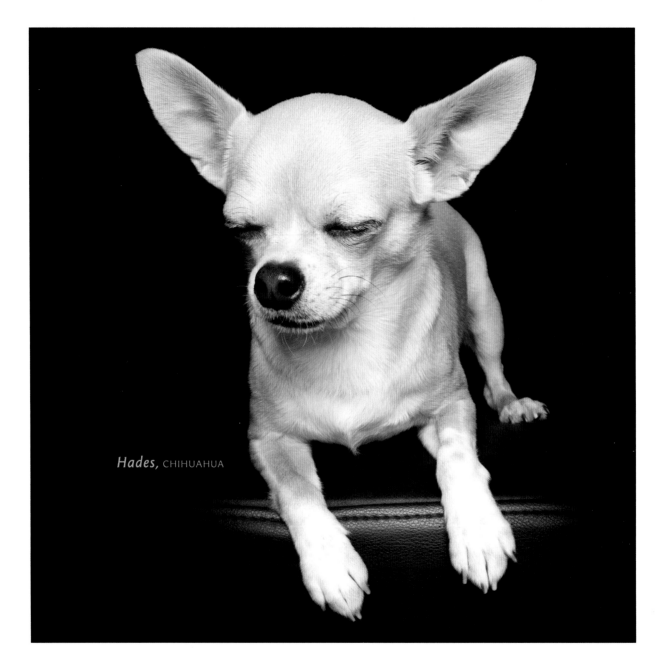

Hades, CHIHUAHUA

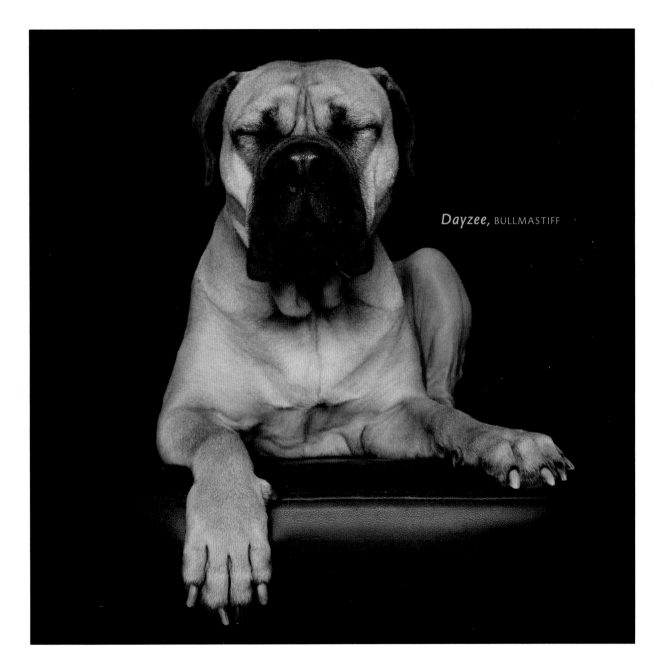

Dayzee, BULLMASTIFF

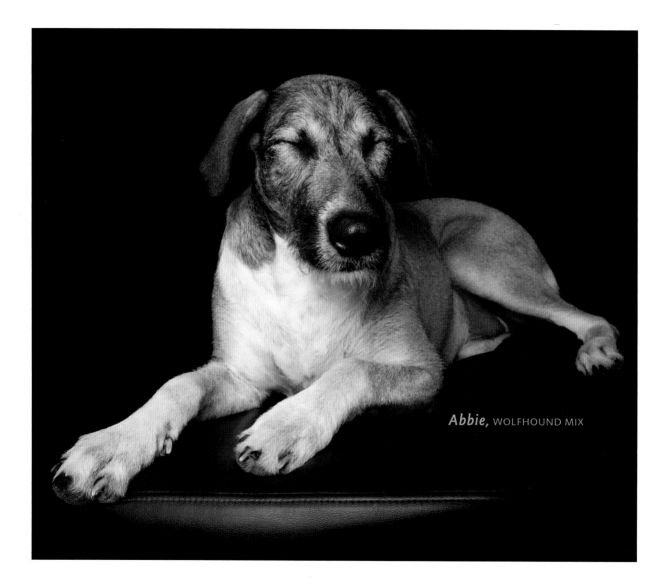

Abbie, WOLFHOUND MIX

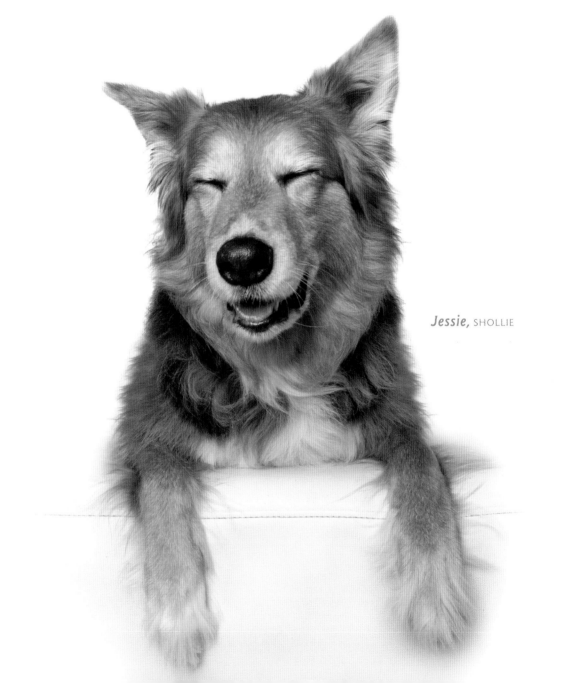

Jessie, SHOLLIE

Nothing is left to you at this moment but to have a good laugh.

—CHINESE ZEN MASTER

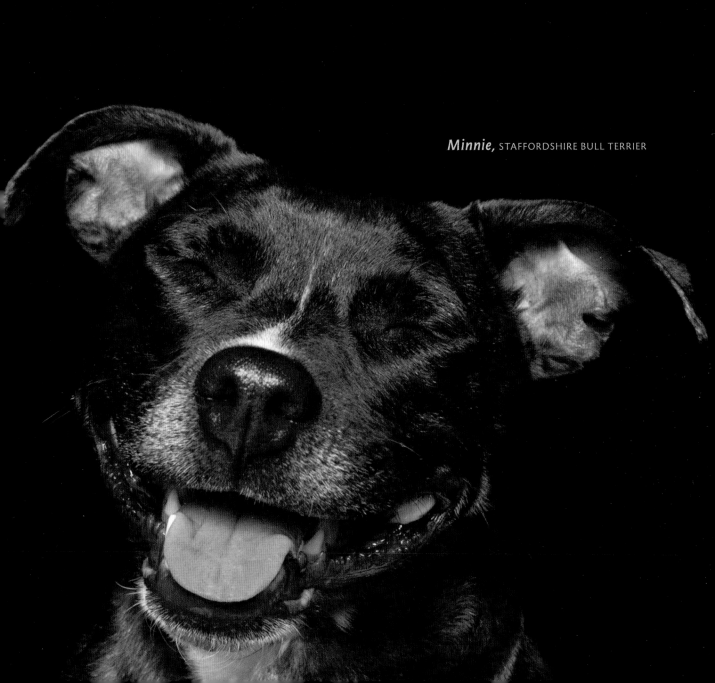

Minnie, STAFFORDSHIRE BULL TERRIER

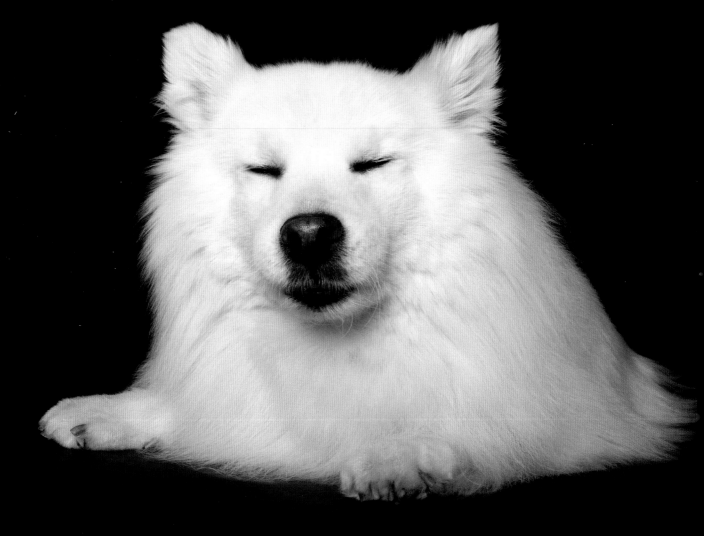

Mr. Scruffy, MIXED BREED

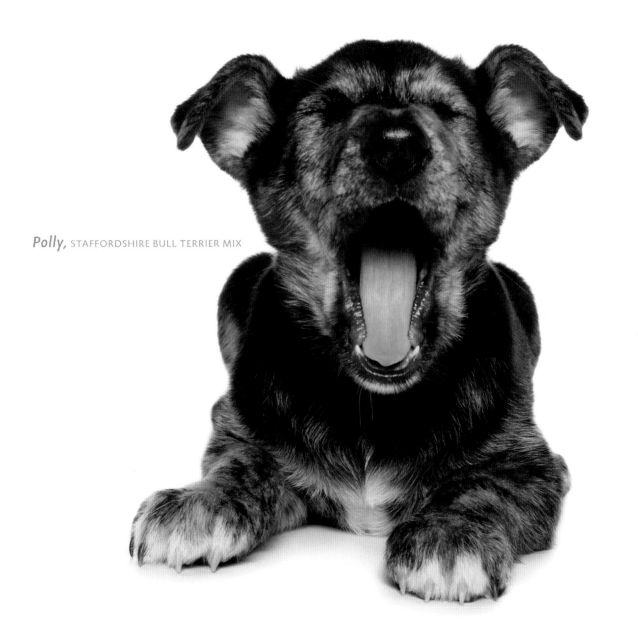

Polly, STAFFORDSHIRE BULL TERRIER MIX

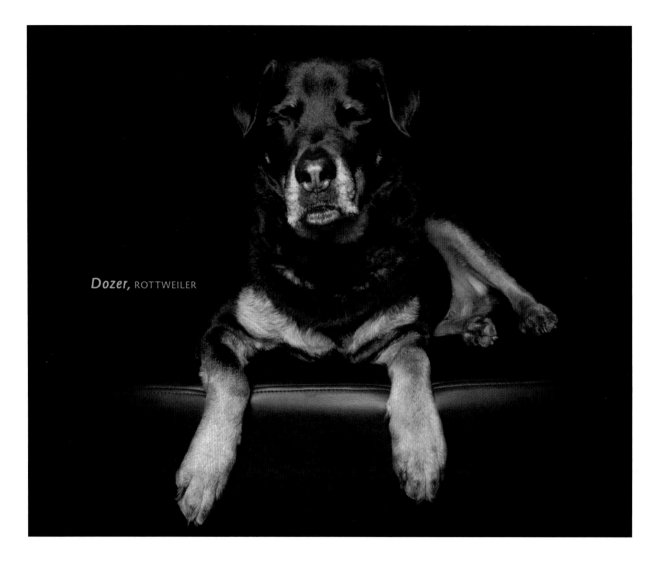

Dozer, ROTTWEILER

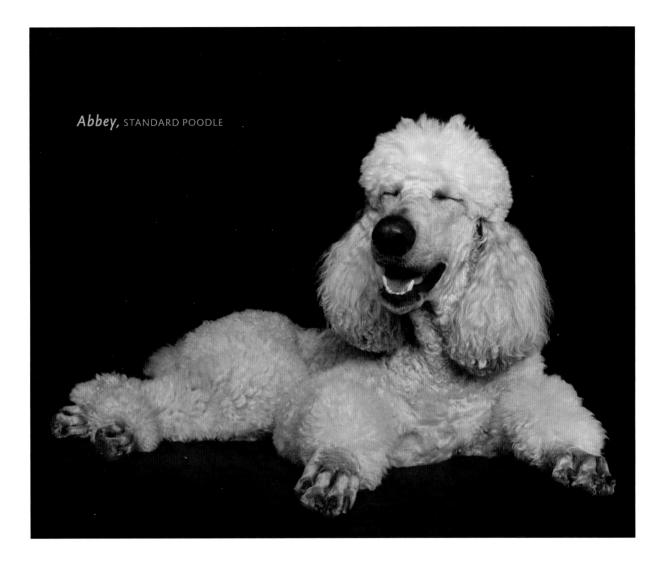

Abbey, STANDARD POODLE

The question is not what you look at, but what you see.

—HENRY DAVID THOREAU

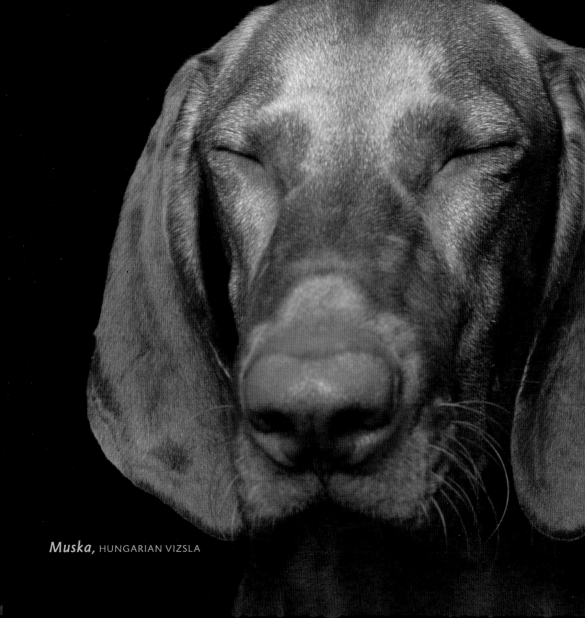

Muska, HUNGARIAN VIZSLA

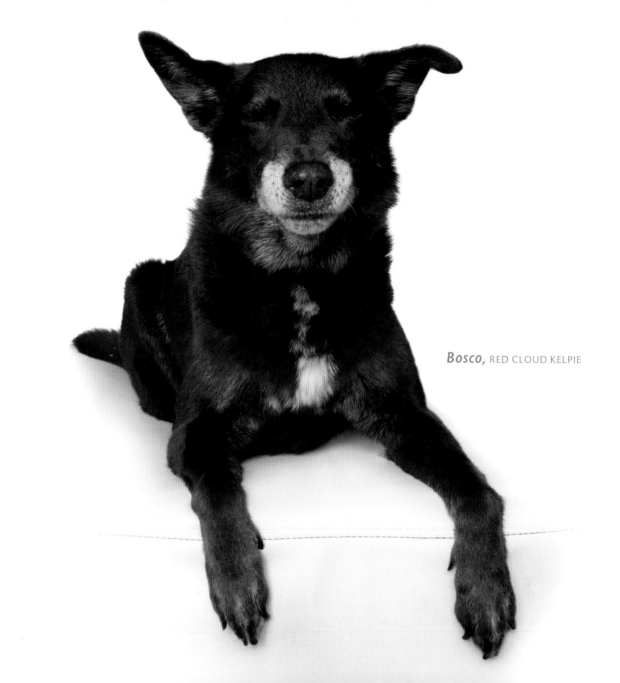

Bosco, RED CLOUD KELPIE

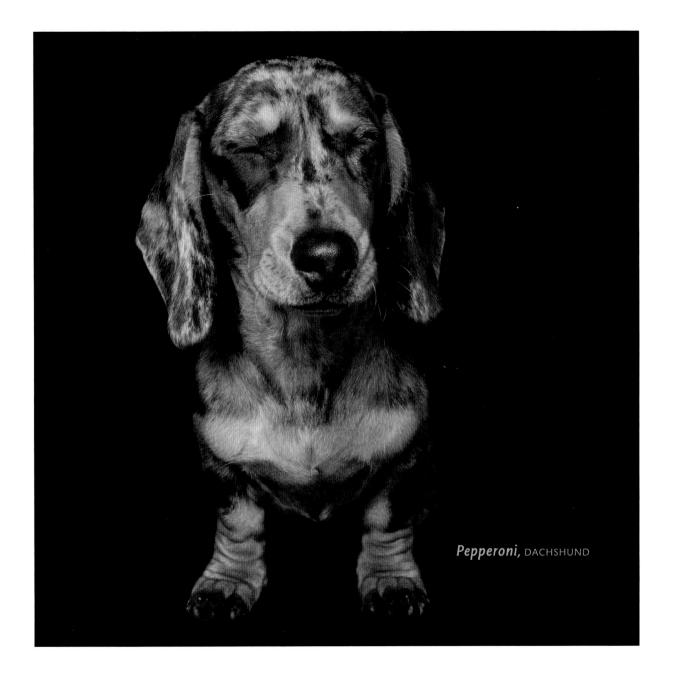

Pepperoni, DACHSHUND

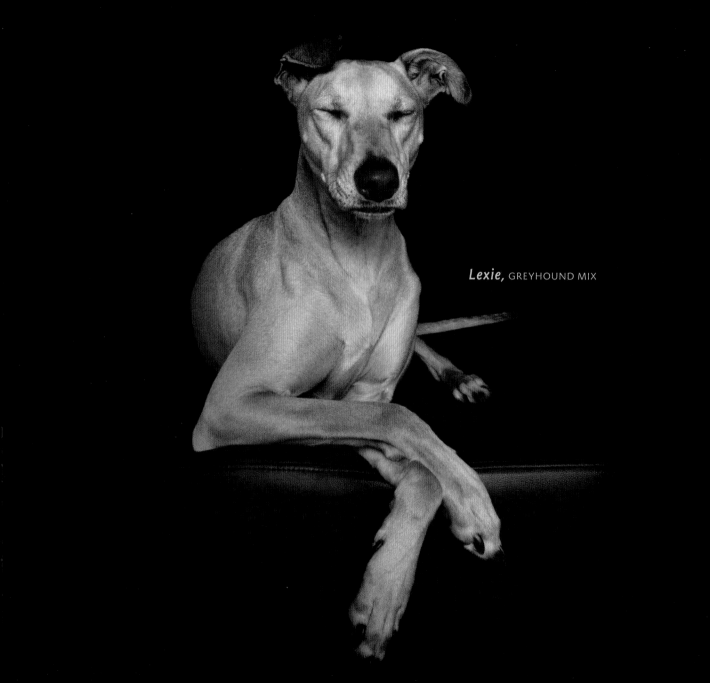

Lexie, GREYHOUND MIX

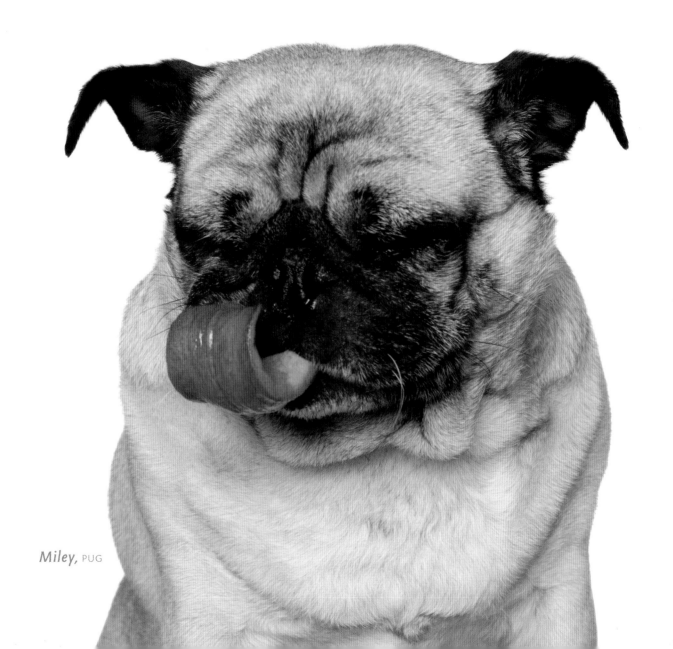

Miley, PUG

You should sit in meditation for twenty minutes a day,
unless you're too busy. Then you should sit for an hour.

—ZEN PROVERB

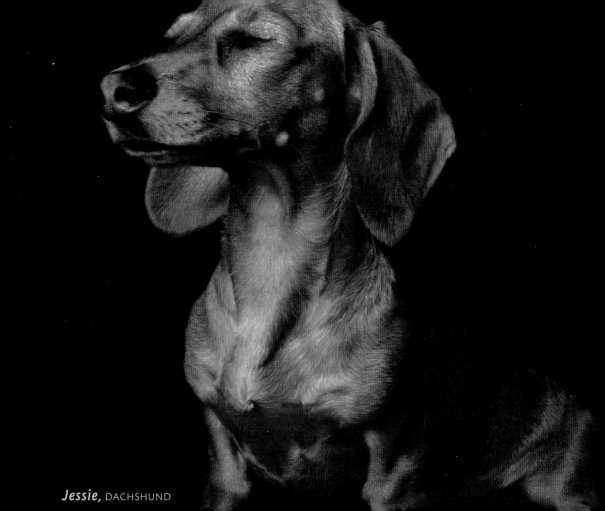

Jessie, DACHSHUND

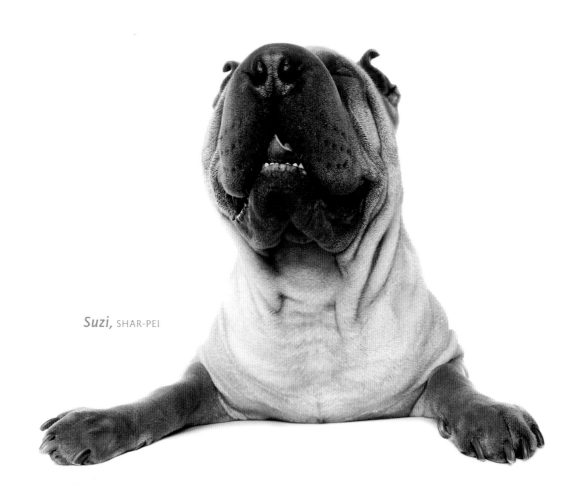

Suzi, SHAR-PEI

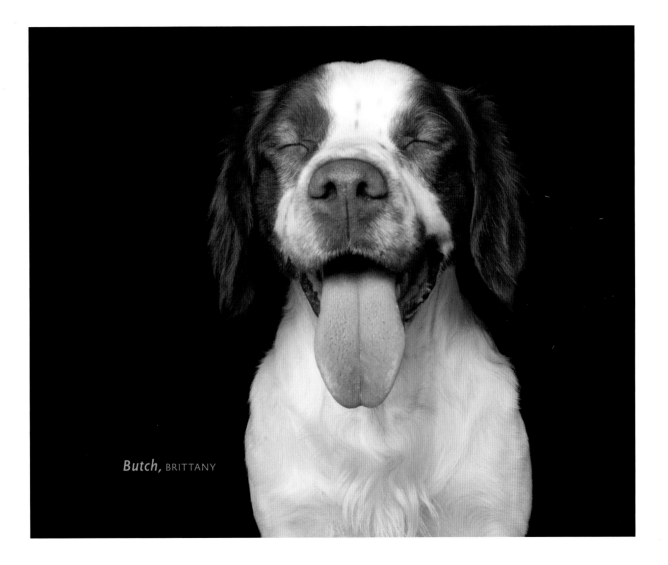

Butch, BRITTANY

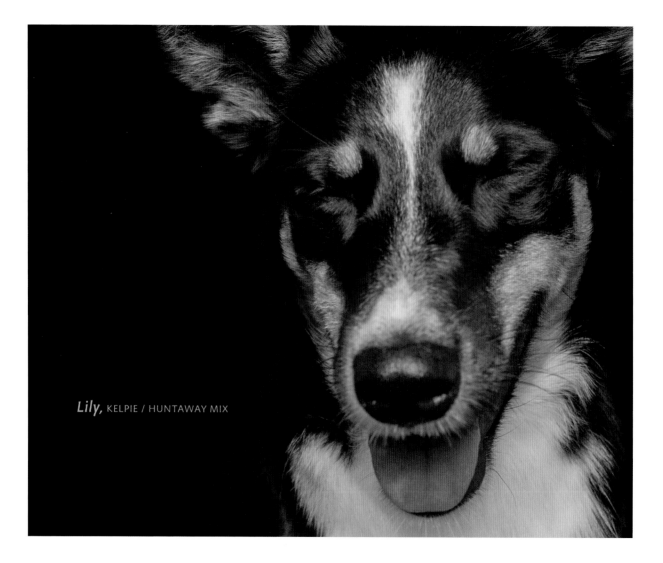

Lily, KELPIE / HUNTAWAY MIX

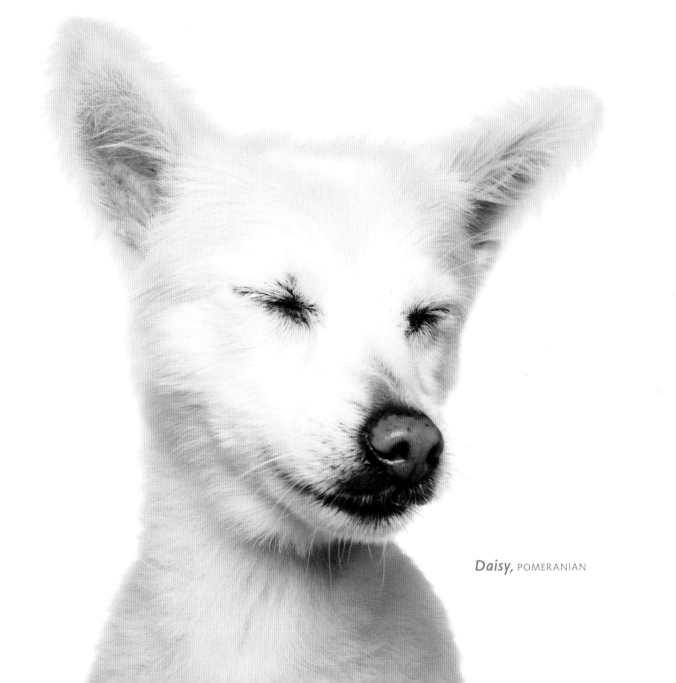

Daisy, POMERANIAN

There is more to life than increasing its speed.

—GANDHI

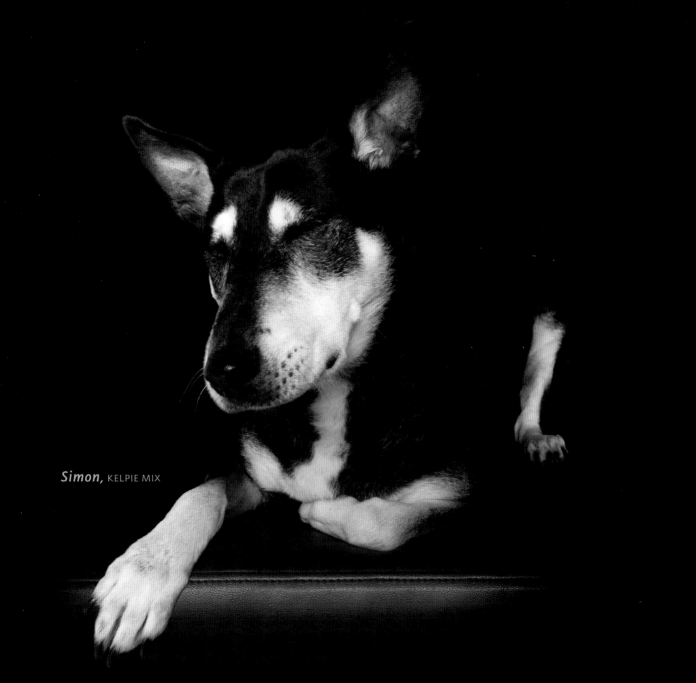

Simon, KELPIE MIX

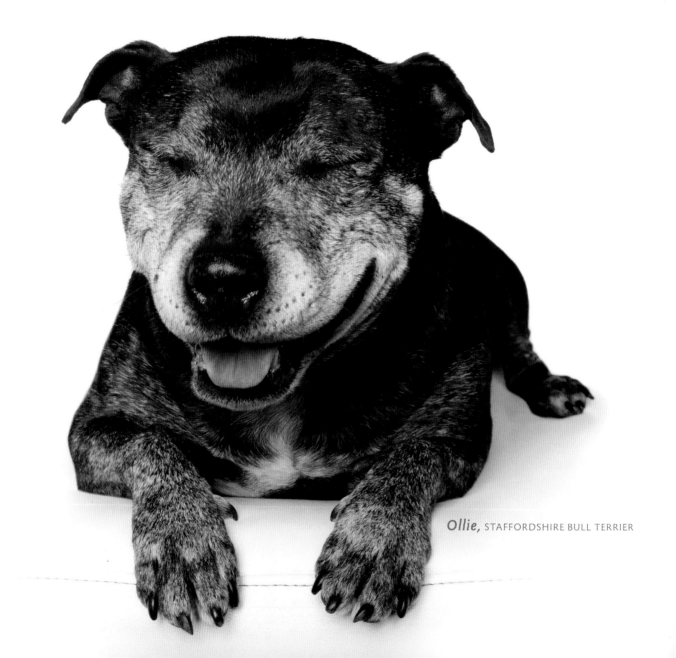

Ollie, STAFFORDSHIRE BULL TERRIER

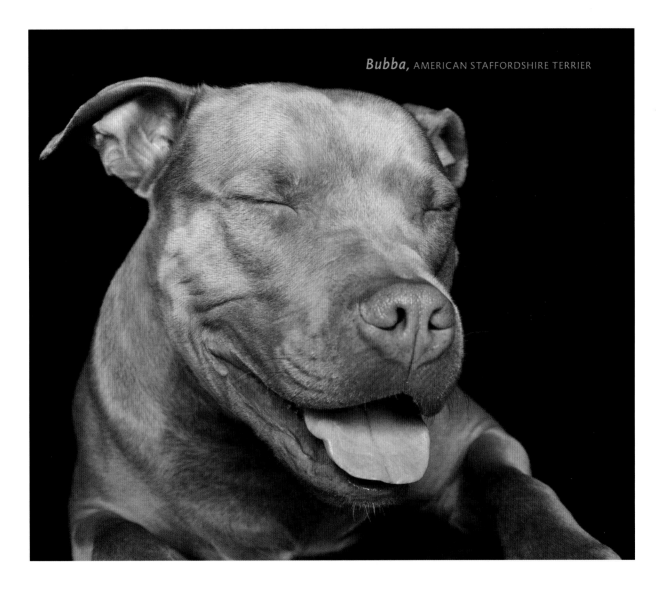

Bubba, AMERICAN STAFFORDSHIRE TERRIER

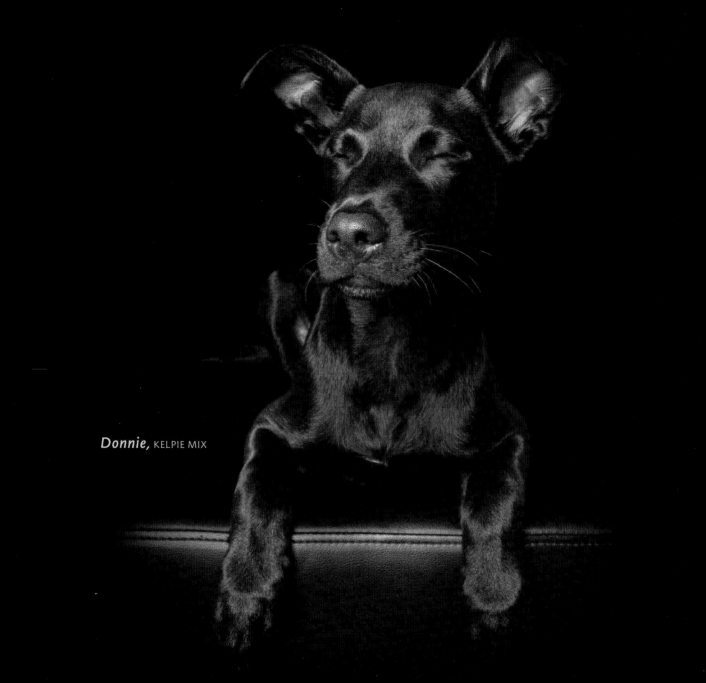

Donnie, KELPIE MIX

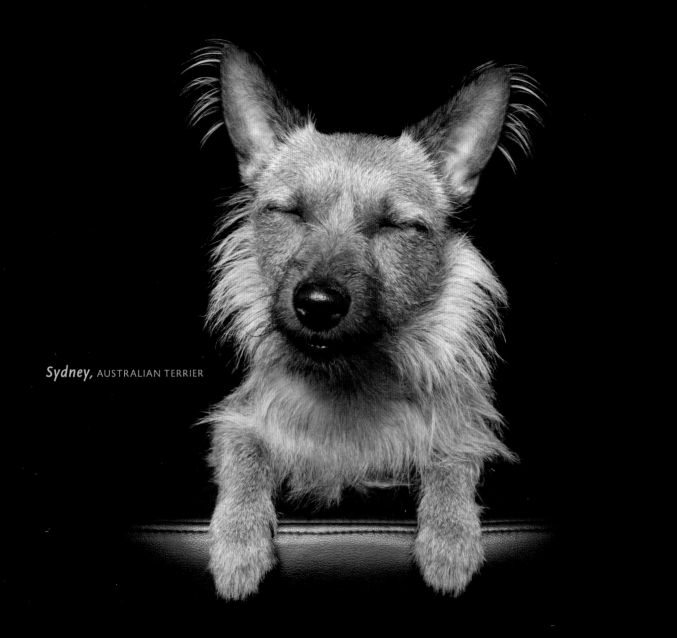

Sydney, AUSTRALIAN TERRIER

*If you are unable to find the truth right where you are,
where else do you expect to find it?*

—DOGEN

Ned, BORDER COLLIE

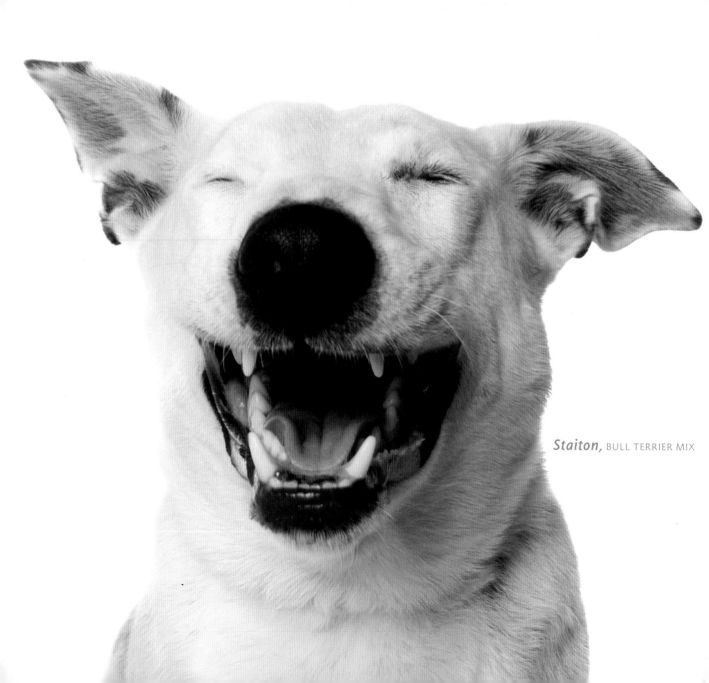

Staiton, BULL TERRIER MIX

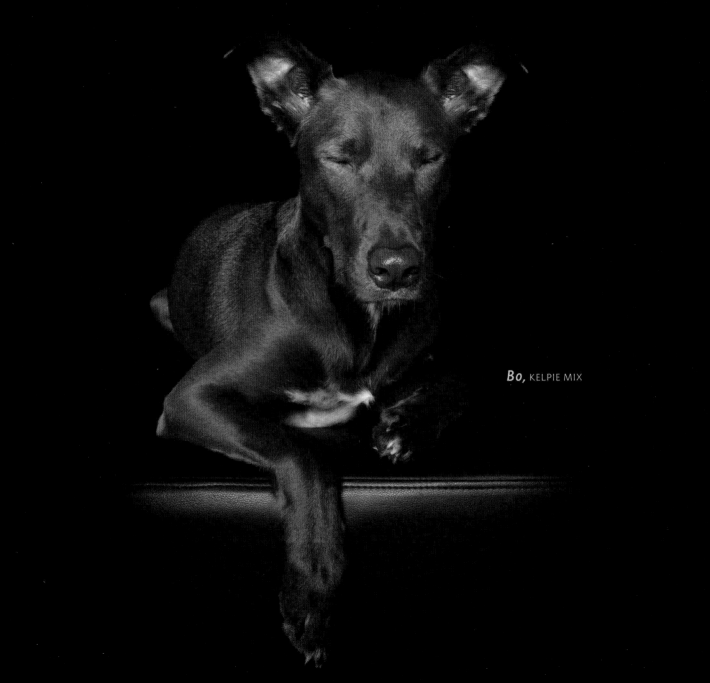

Bo, KELPIE MIX

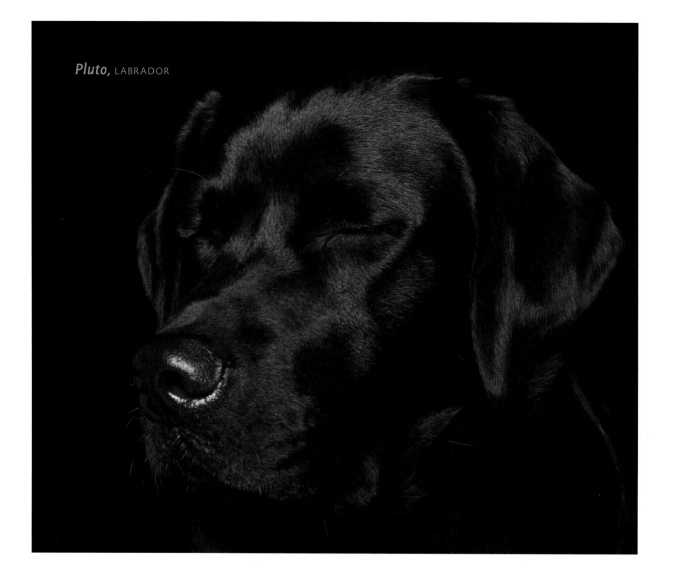

Pluto, LABRADOR

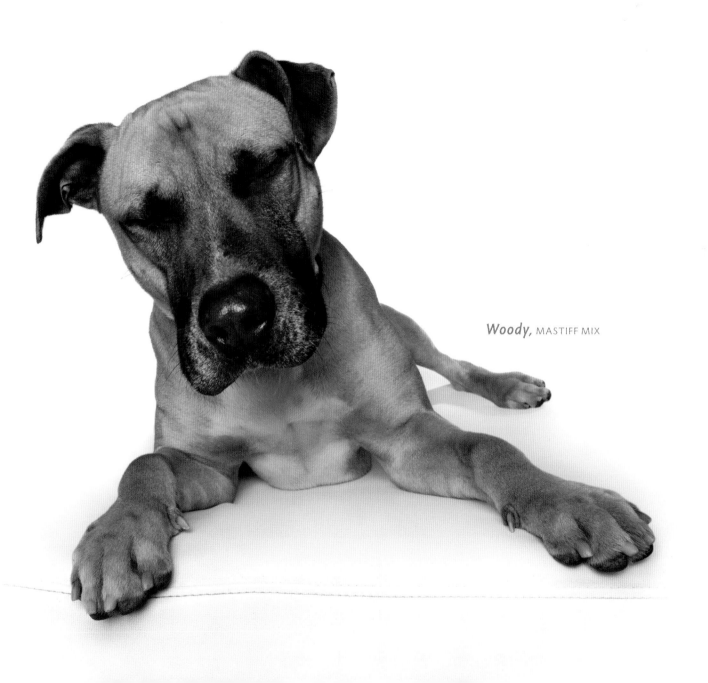

Woody, MASTIFF MIX

The pursuit, even of the best things, ought to be calm and tranquil.

—MARCUS TULLIUS CICERO

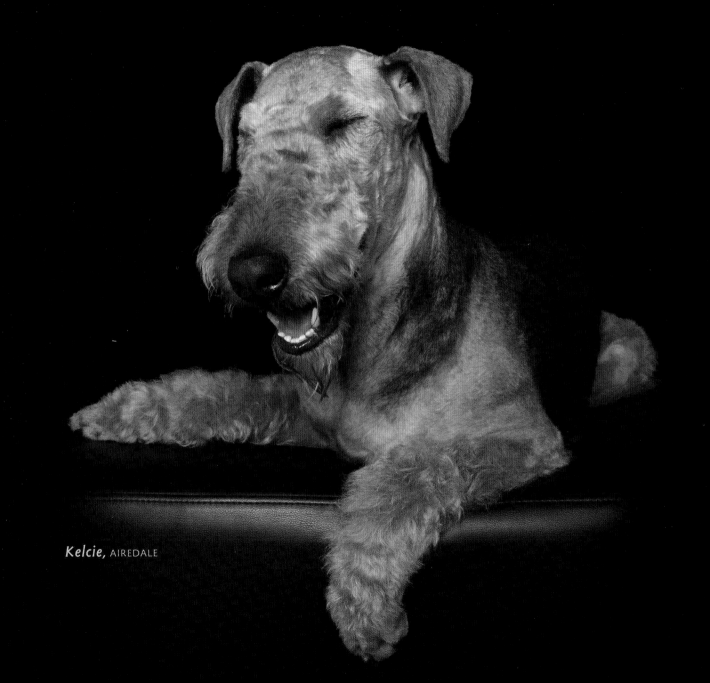

Kelcie, AIREDALE

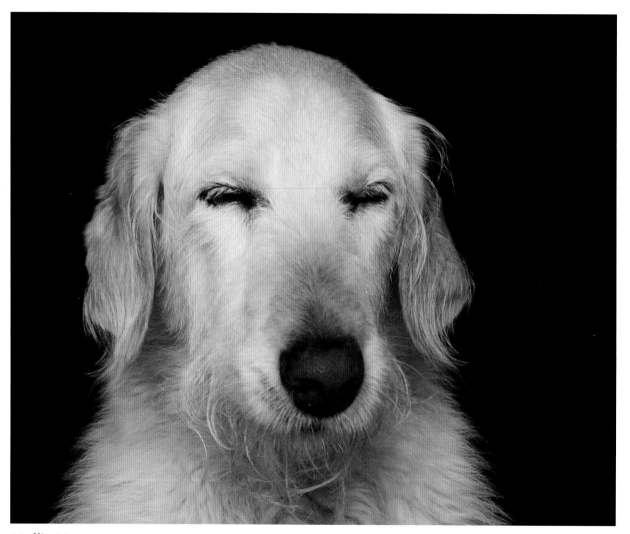

Mollie Moo, WOLFHOUND / RETRIEVER MIX

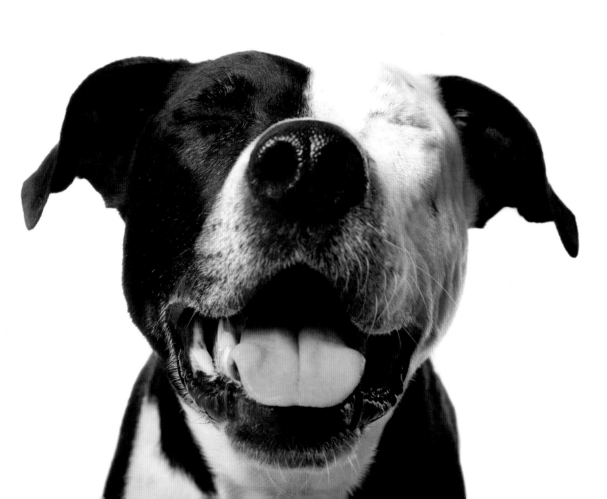

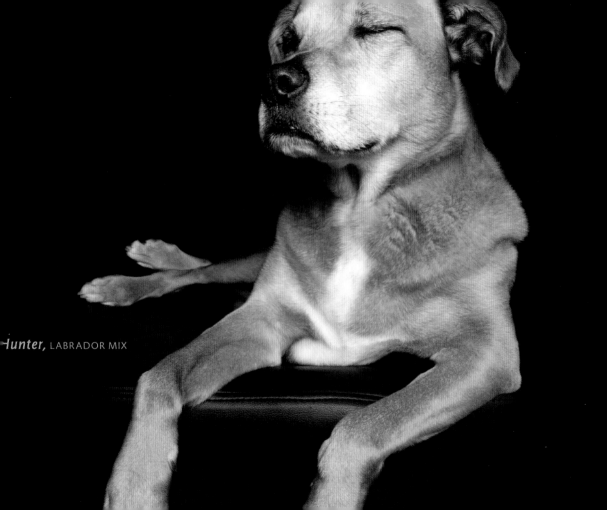

Hunter, LABRADOR MIX

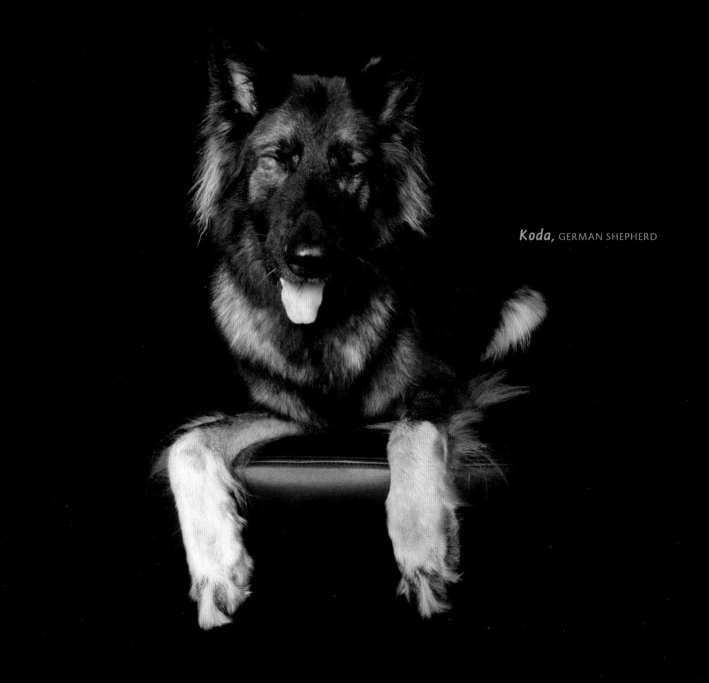

Koda, GERMAN SHEPHERD

Peace is always beautiful.

—WALT WHITMAN

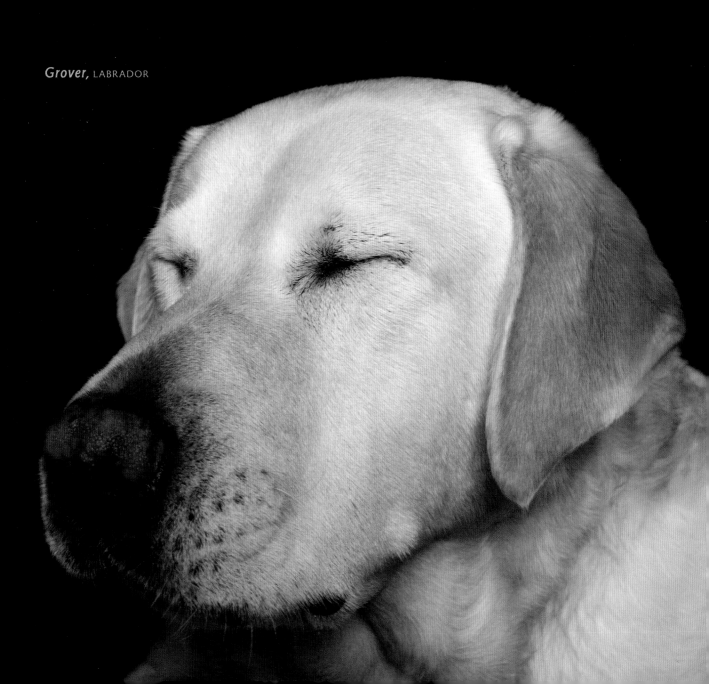

Grover, LABRADOR

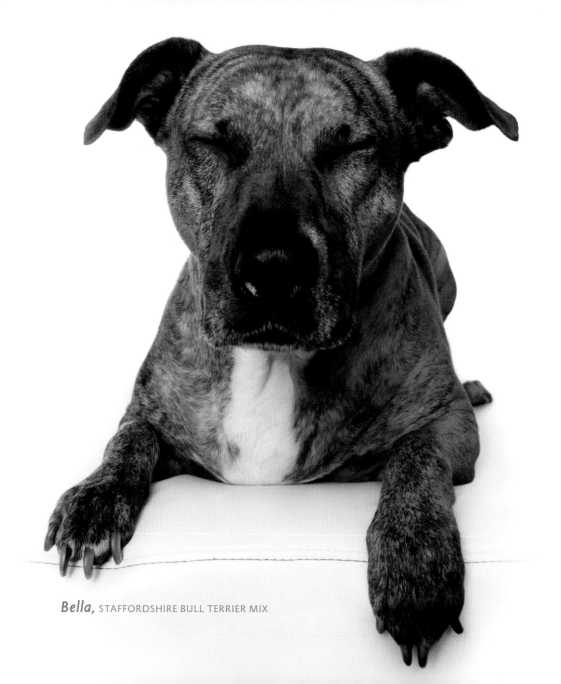

Bella, STAFFORDSHIRE BULL TERRIER MIX

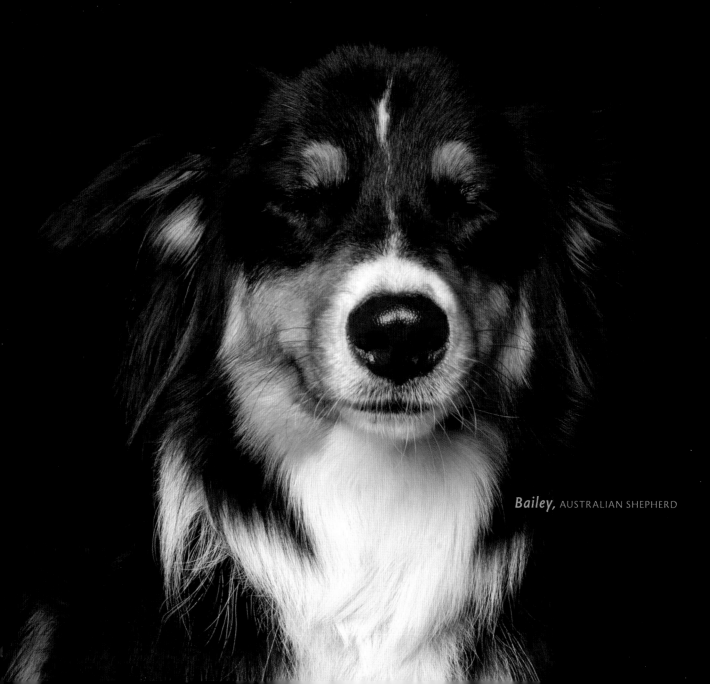

Bailey, AUSTRALIAN SHEPHERD

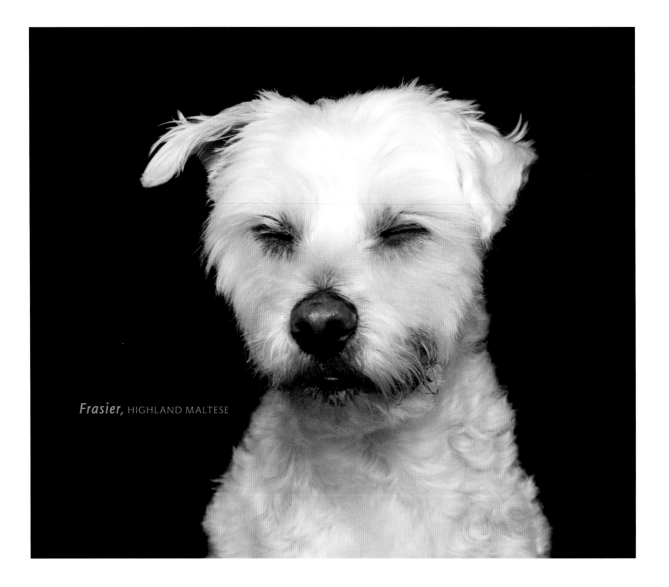

Frasier, HIGHLAND MALTESE

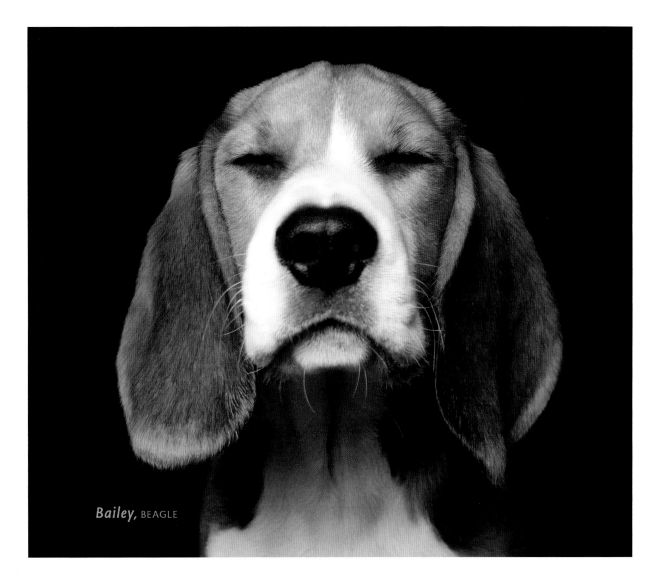

Bailey, BEAGLE

Every situation—nay, every moment—is of infinite worth;
for it is the representative of a whole eternity.

—JOHANN WOLFGANG VON GOETHE

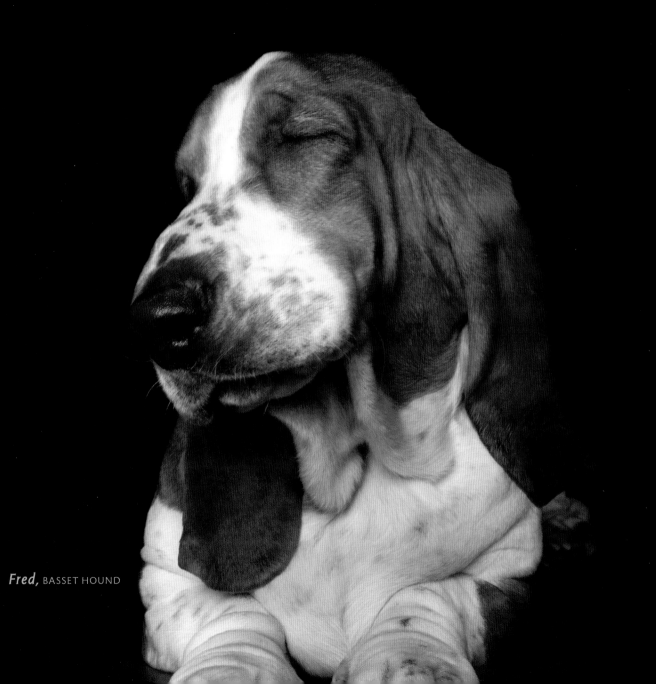

Fred, BASSET HOUND

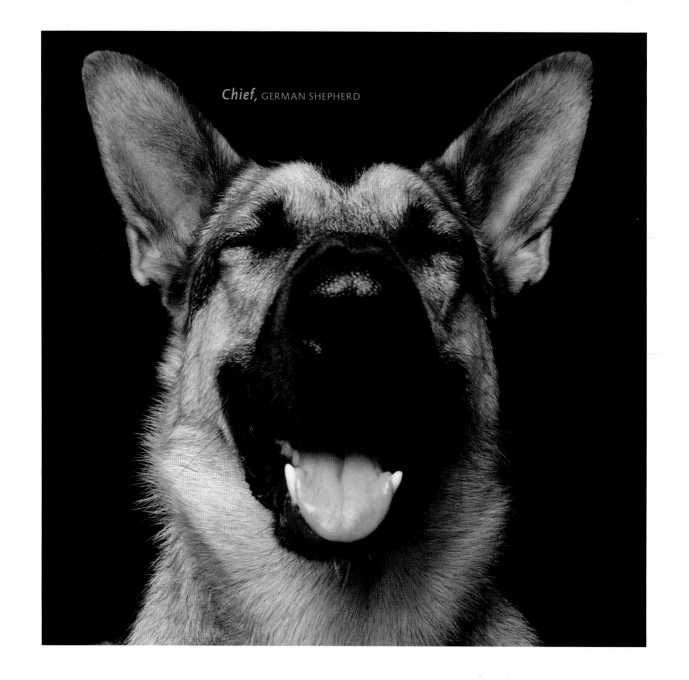

Chief, GERMAN SHEPHERD

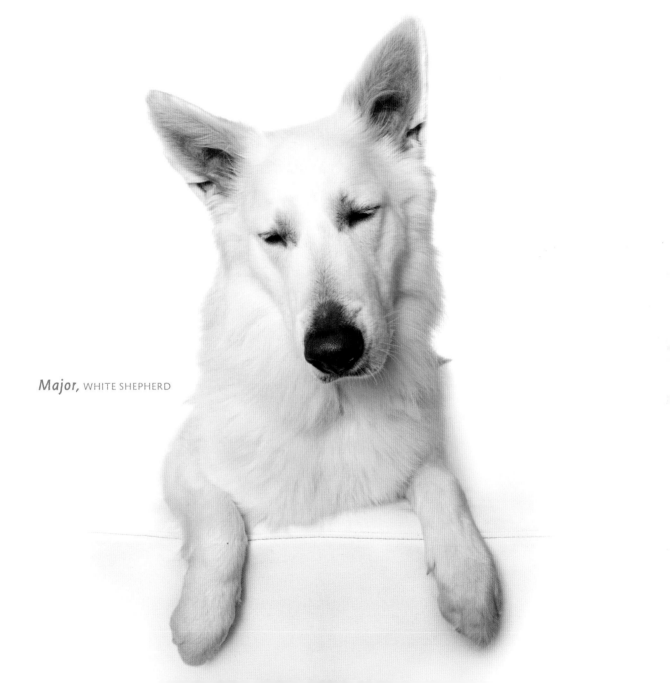

Major, WHITE SHEPHERD

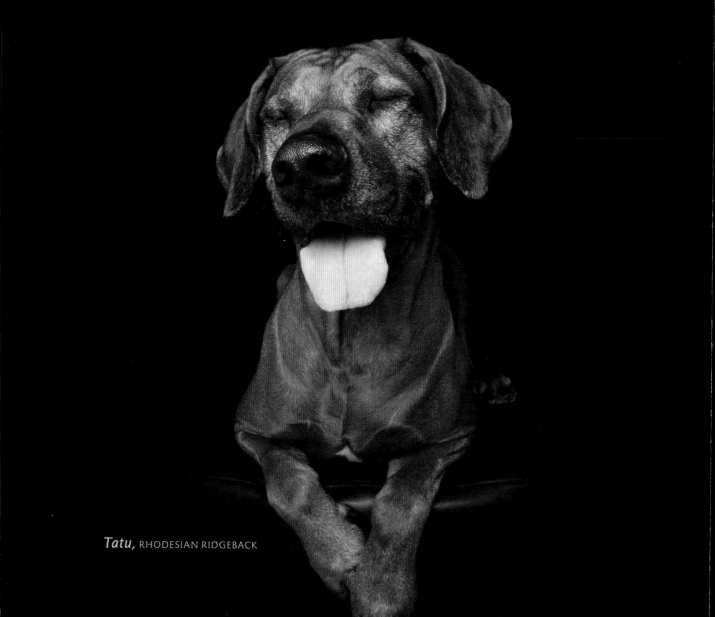

Tatu, RHODESIAN RIDGEBACK

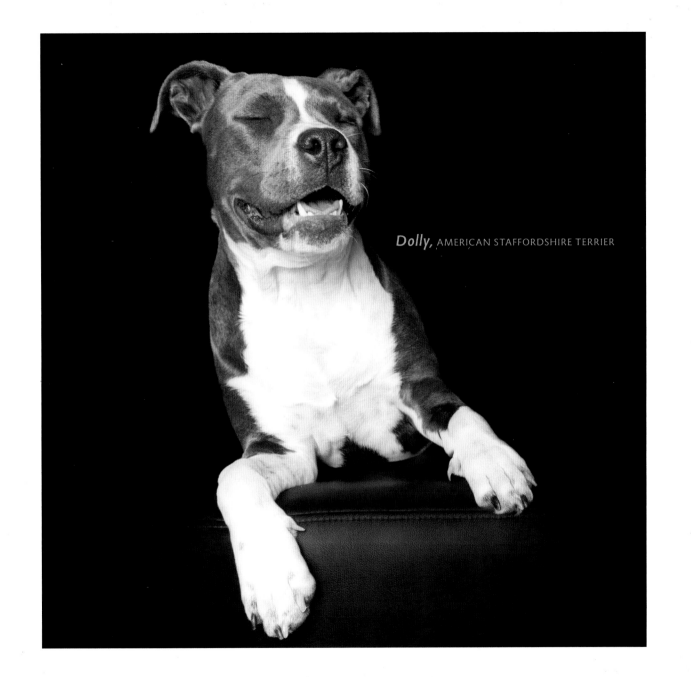

Dolly, AMERICAN STAFFORDSHIRE TERRIER

May all beings have happy minds.

—BUDDHA

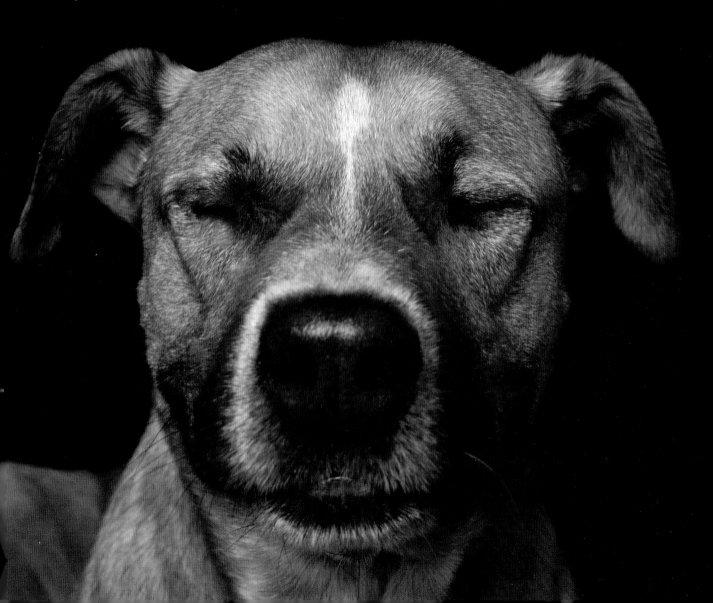

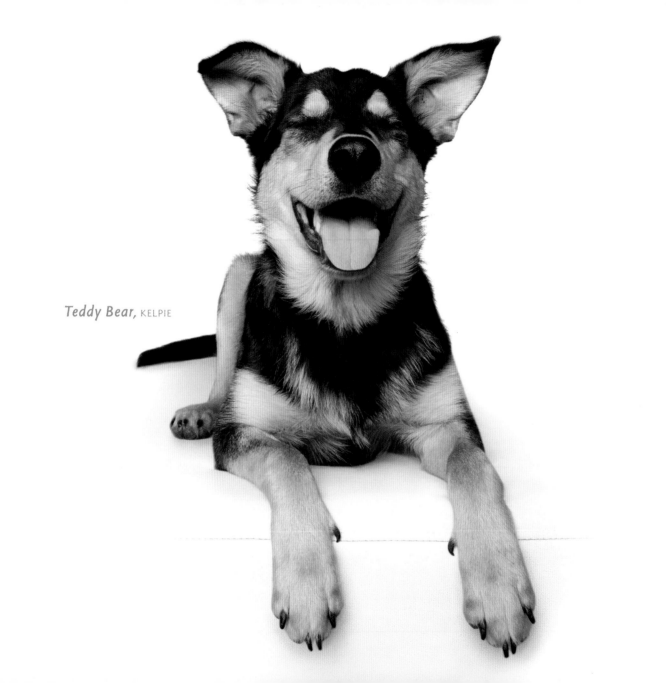

Teddy Bear, KELPIE

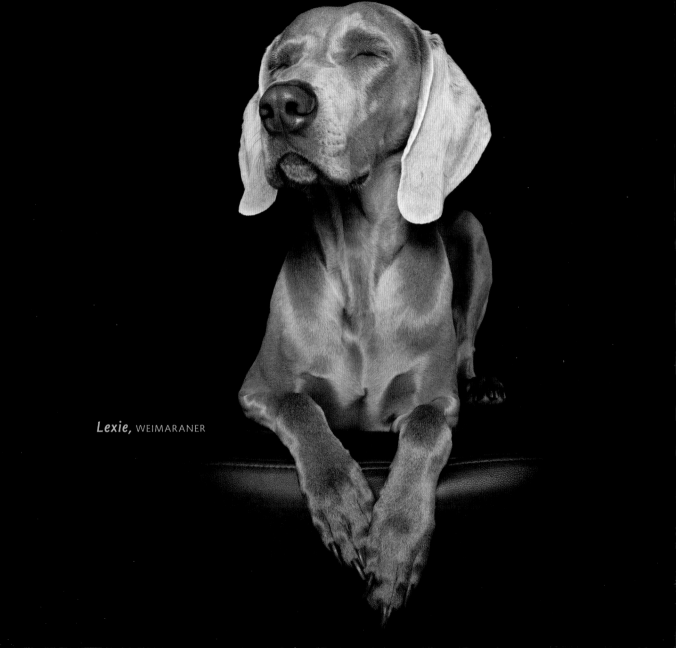

Lexie, WEIMARANER

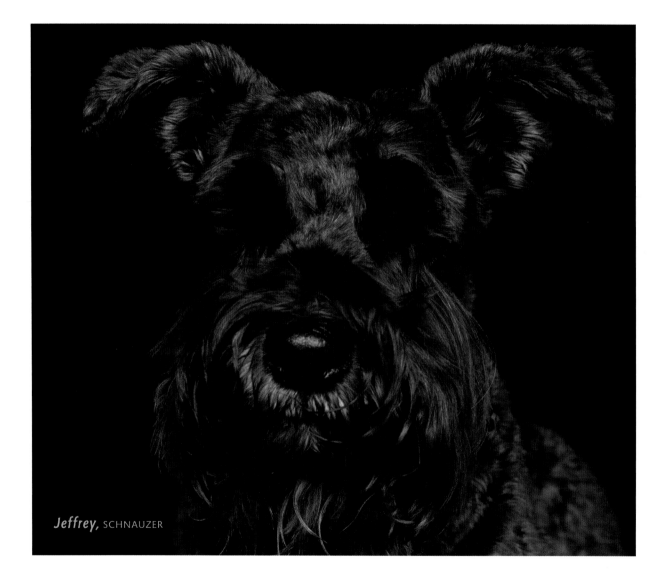

Jeffrey, SCHNAUZER

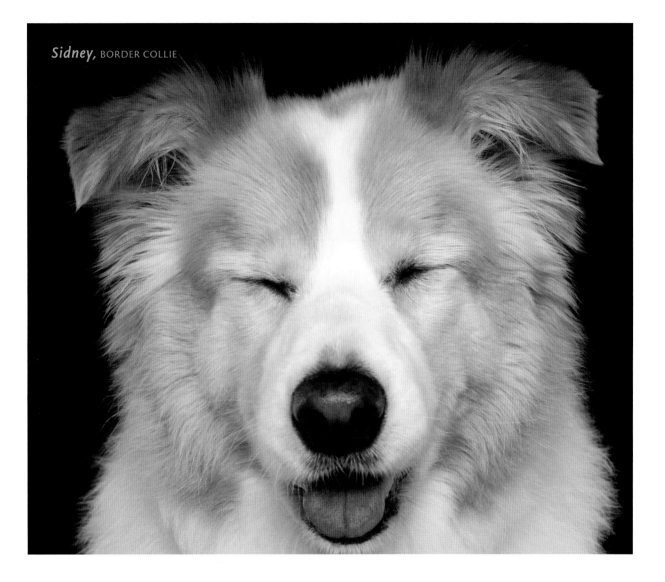

Sidney, BORDER COLLIE

Nothing can bring you peace but yourself.

—RALPH WALDO EMERSON

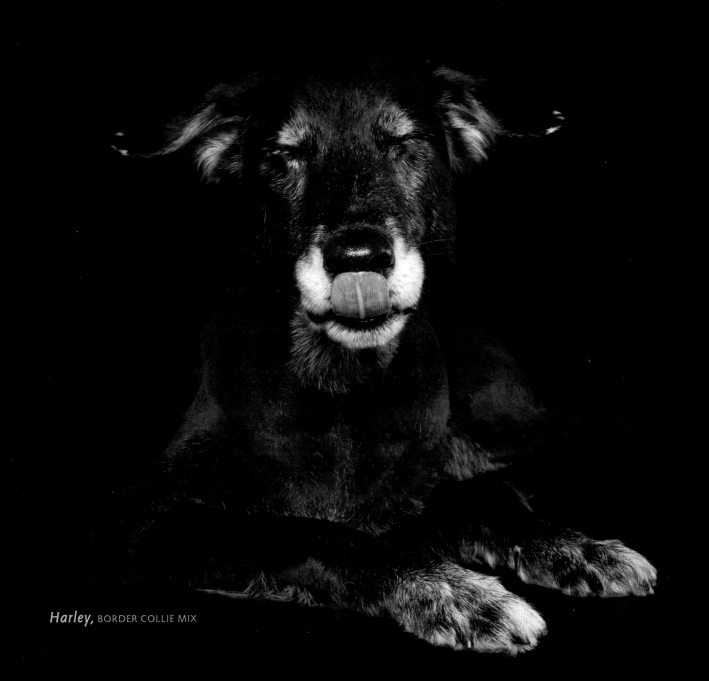

Harley, BORDER COLLIE MIX

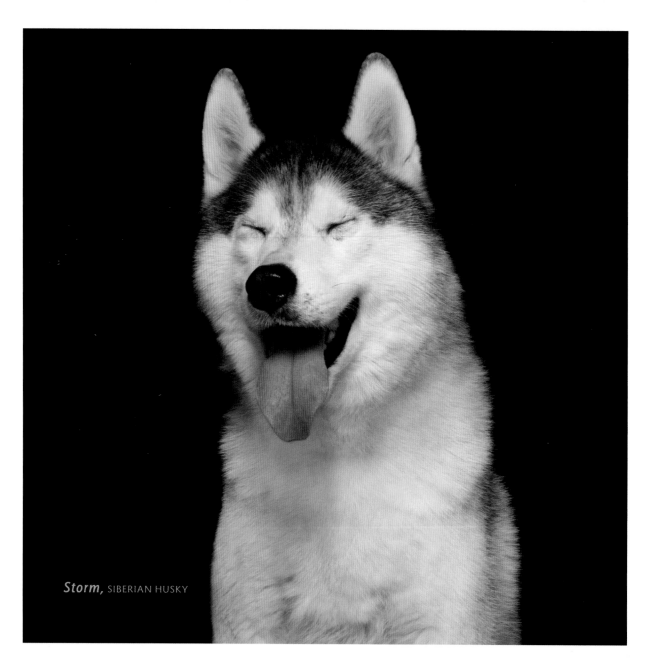

Storm, SIBERIAN HUSKY

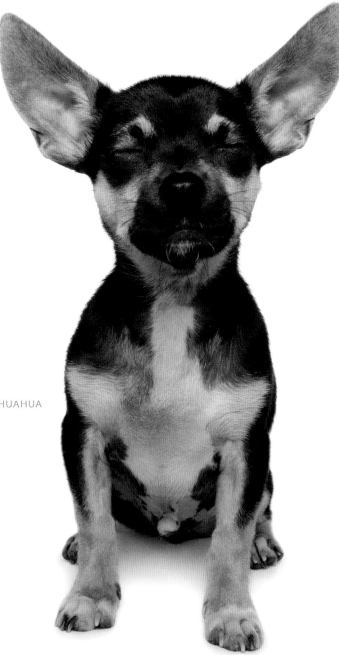

Harry, JACKHUAHUA

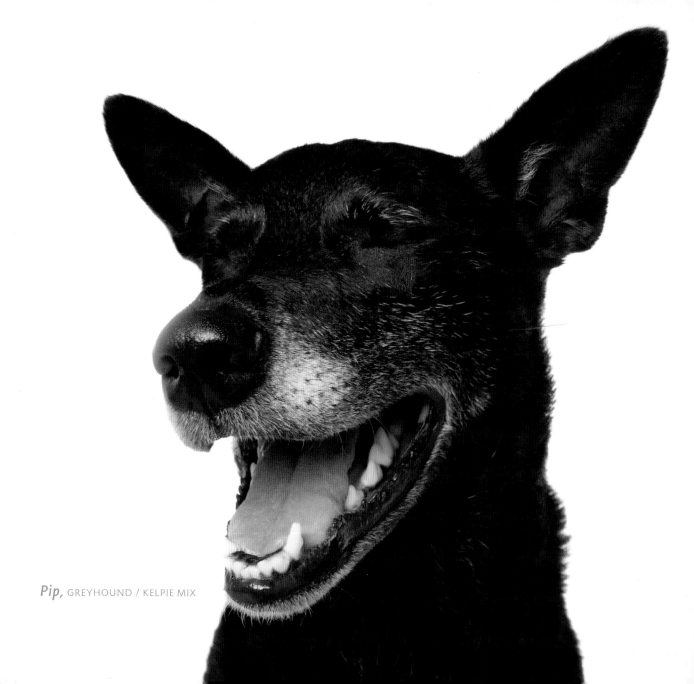

Pip, GREYHOUND / KELPIE MIX

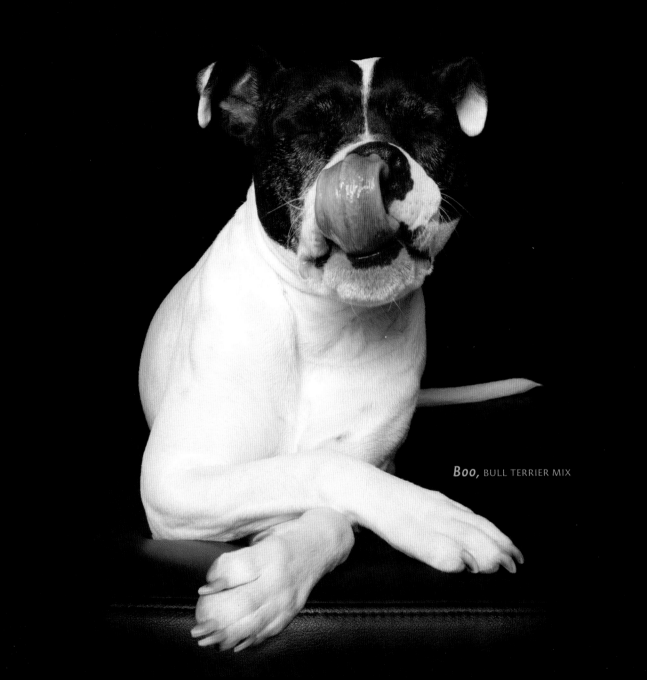
Boo, BULL TERRIER MIX

*Only when you can be extremely pliable and soft
can you be extremely hard and strong.*

—ZEN PROVERB

Sharon, GOLDEN RETRIEVER MIX

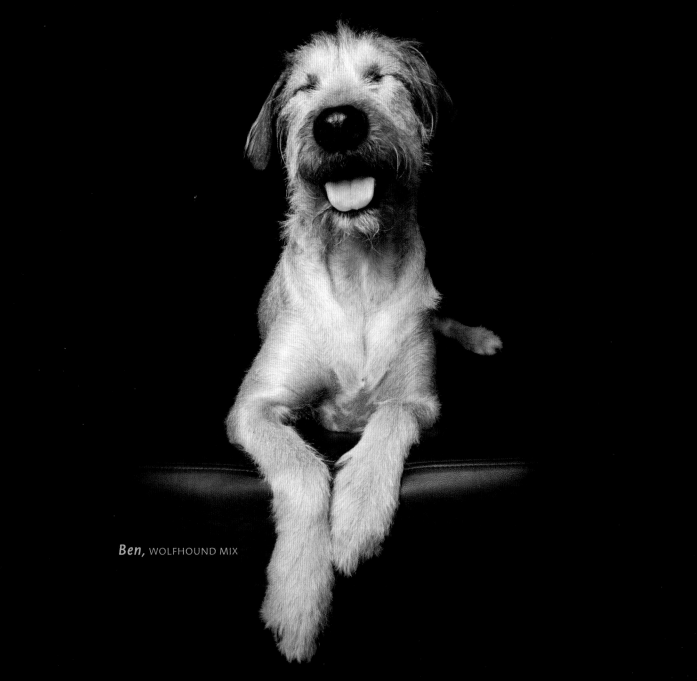

Ben, WOLFHOUND MIX

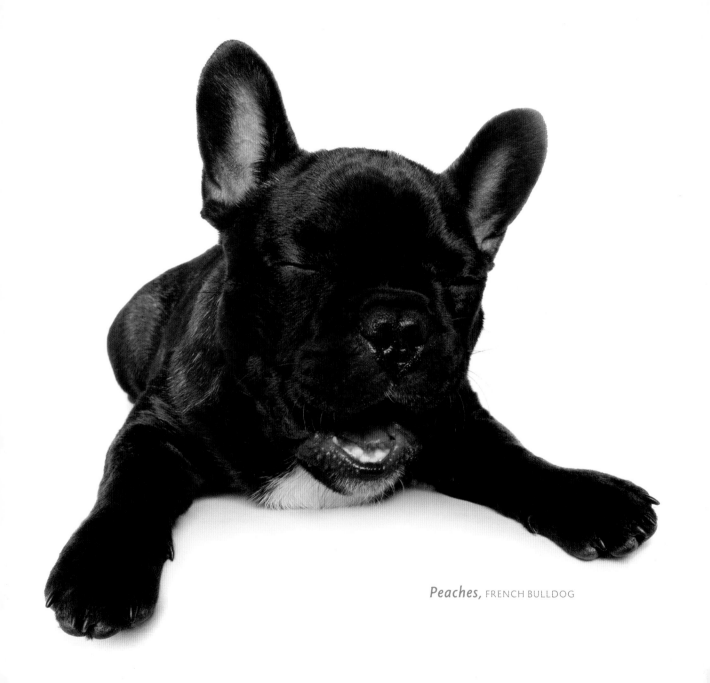

Peaches, FRENCH BULLDOG

The tighter you squeeze, the less you have.

—THOMAS MERTON

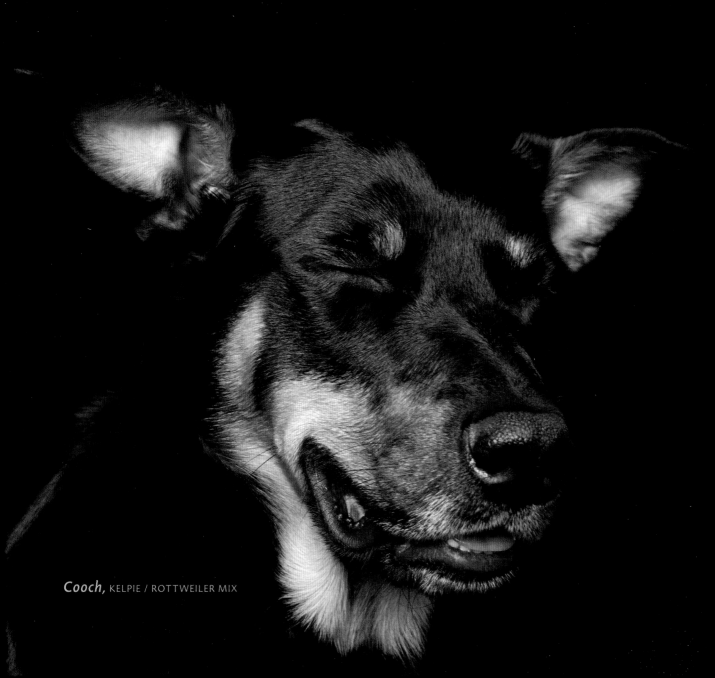

Cooch, KELPIE / ROTTWEILER MIX

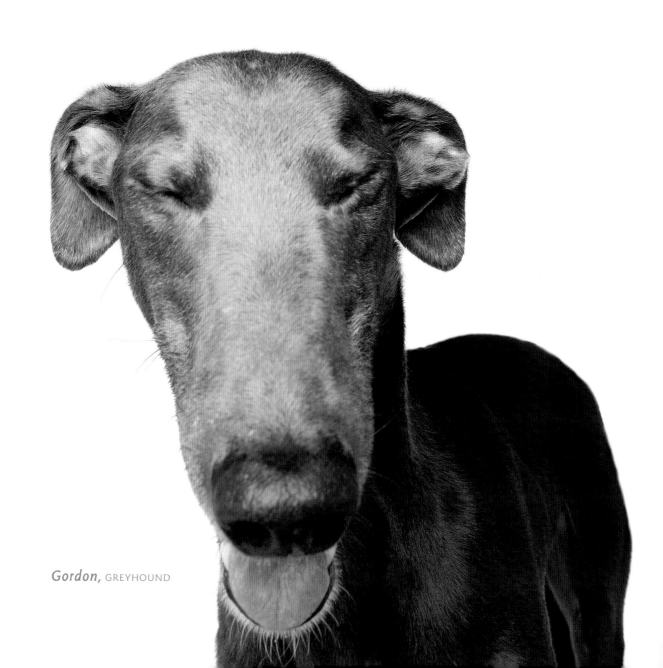

Gordon, GREYHOUND

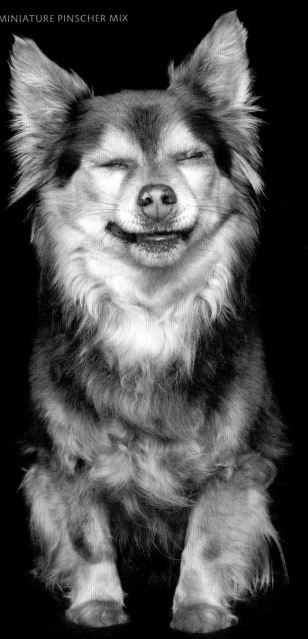

Hairy, CHIHUAHUA / MINIATURE PINSCHER MIX

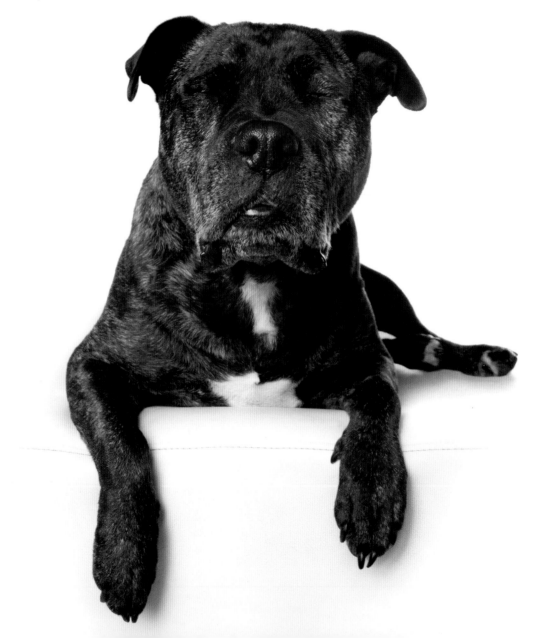

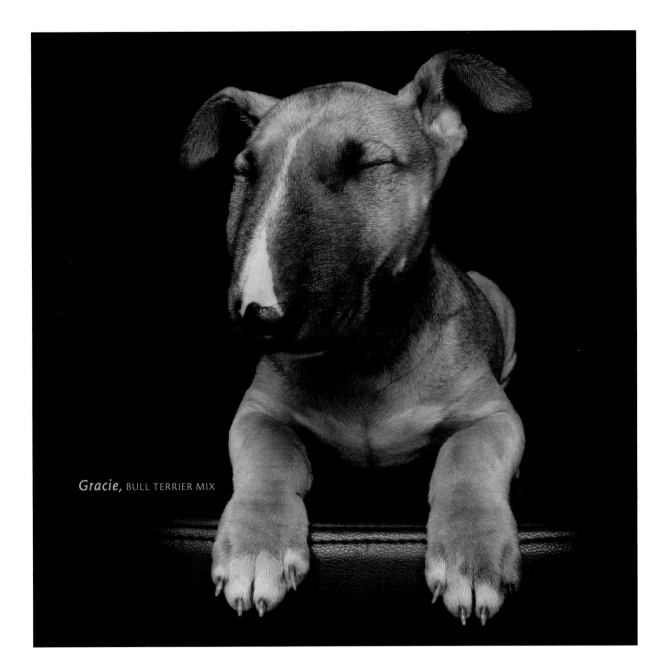

Gracie, BULL TERRIER MIX

If you're always racing to the next moment,
what happens to the one you're in?

—UNKNOWN

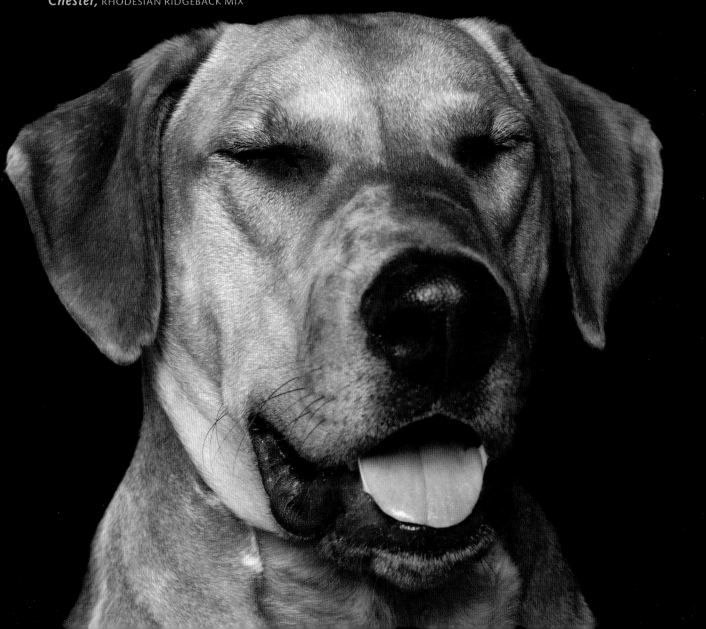

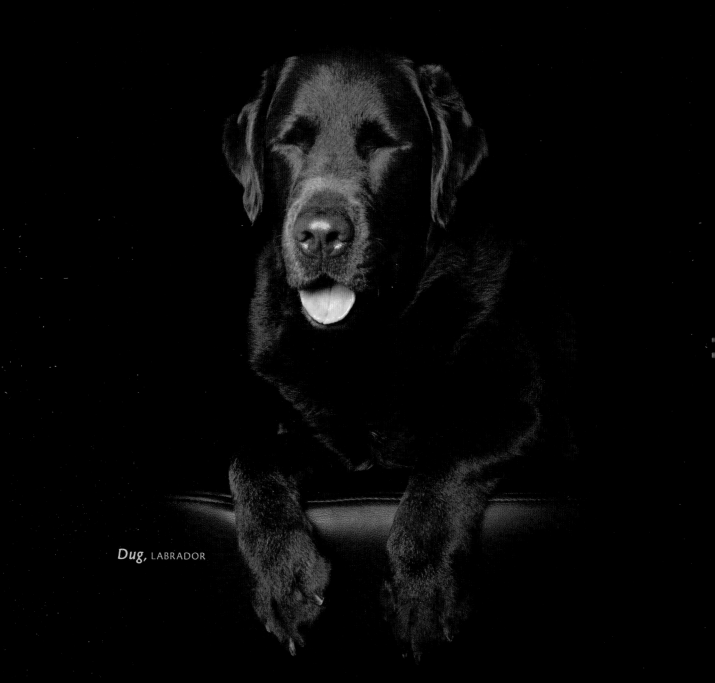

Dug, LABRADOR

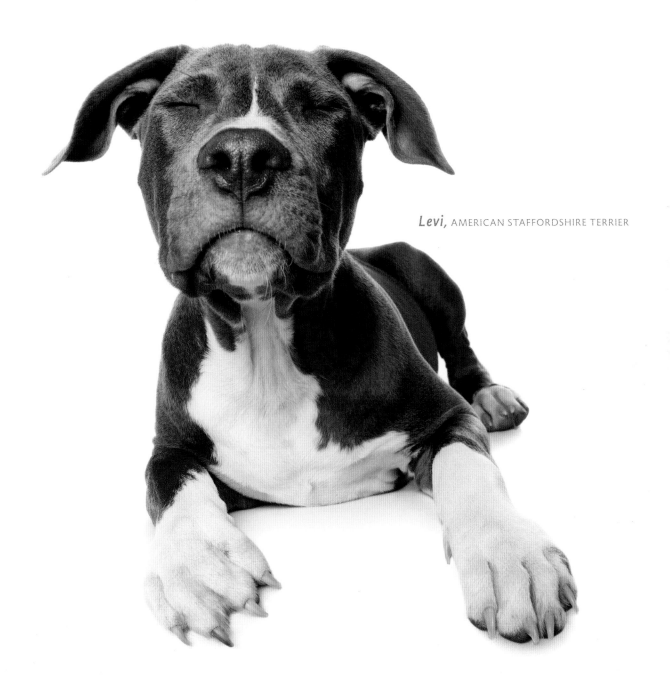

Levi, AMERICAN STAFFORDSHIRE TERRIER

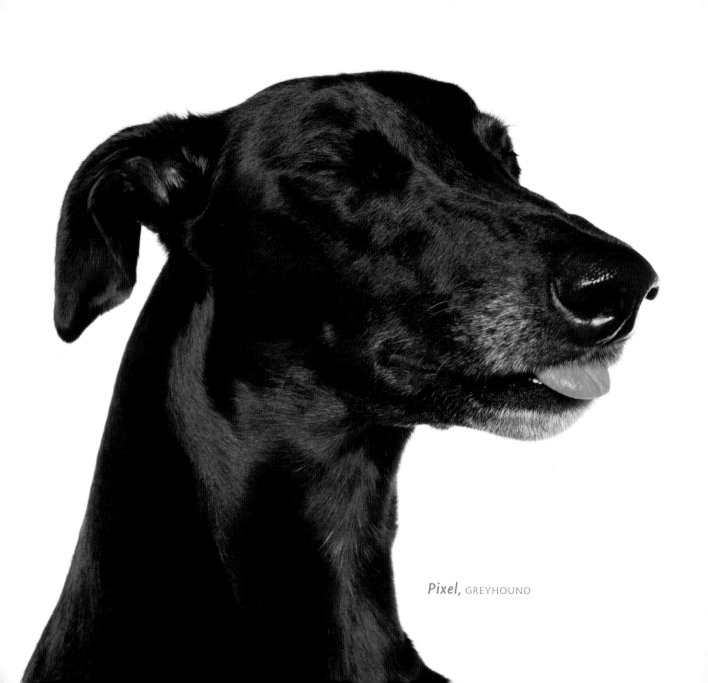

Pixel, GREYHOUND

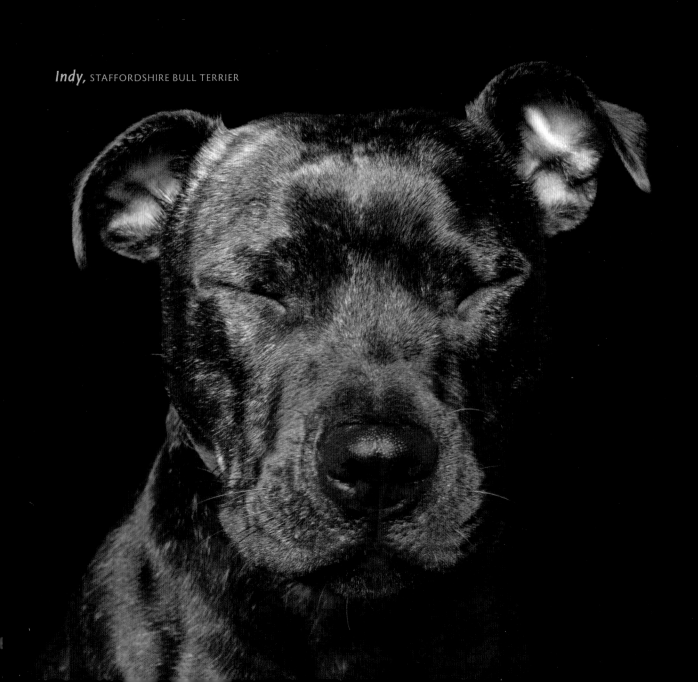

Indy, STAFFORDSHIRE BULL TERRIER

Remember then: there is only one time that is important—Now! It is the most important time because it is the only time when we have any power.

—LEO TOLSTOY

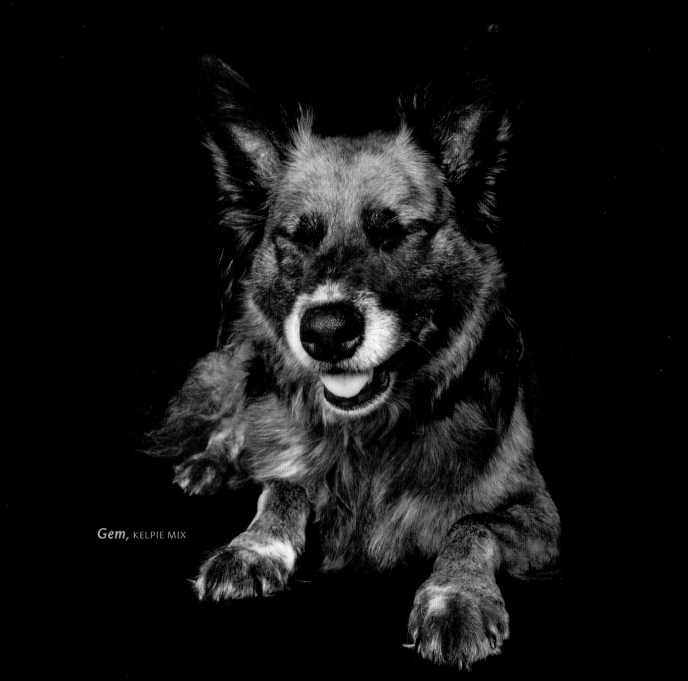

Gem, KELPIE MIX

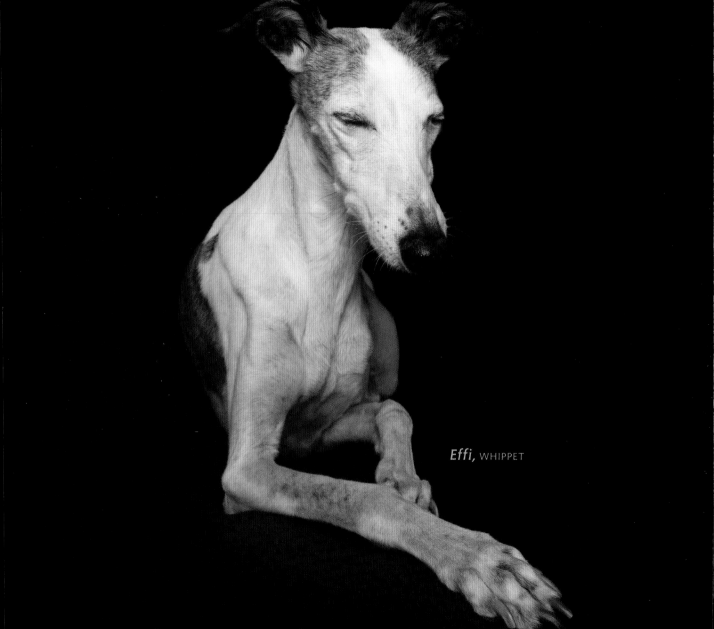

Effi, WHIPPET

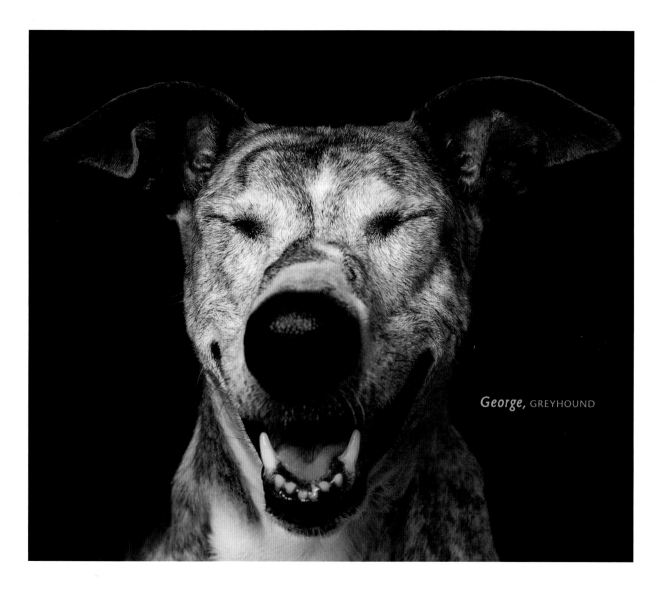

George, GREYHOUND

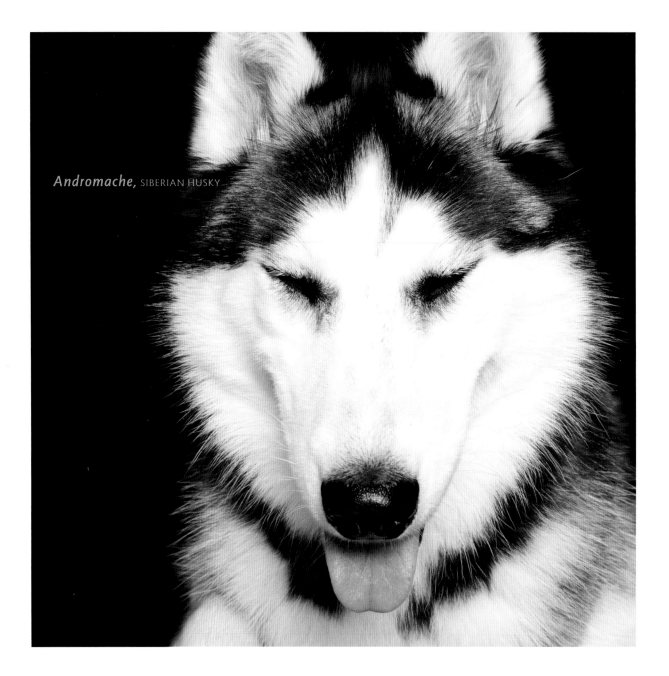

Andromache, SIBERIAN HUSKY

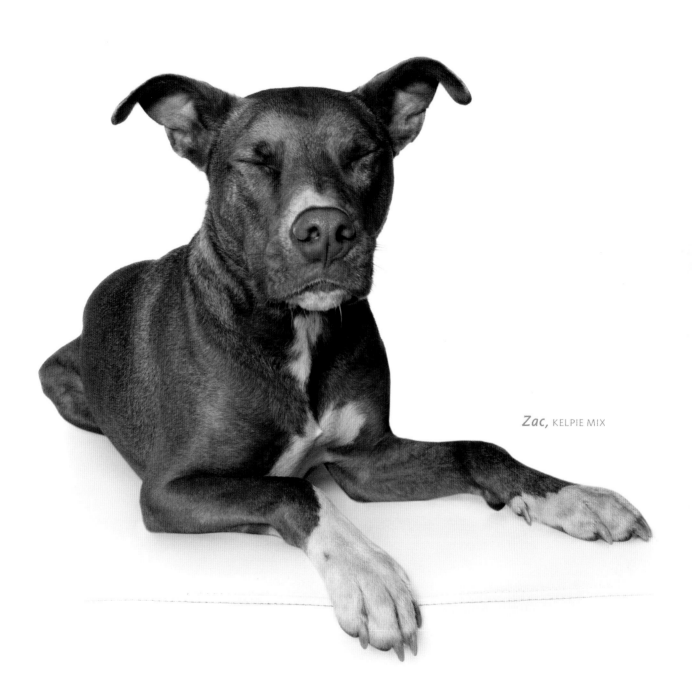

Zac, KELPIE MIX

Where there is peace and meditation, there is neither anxiety nor doubt.

—ST. FRANCIS OF ASSISI

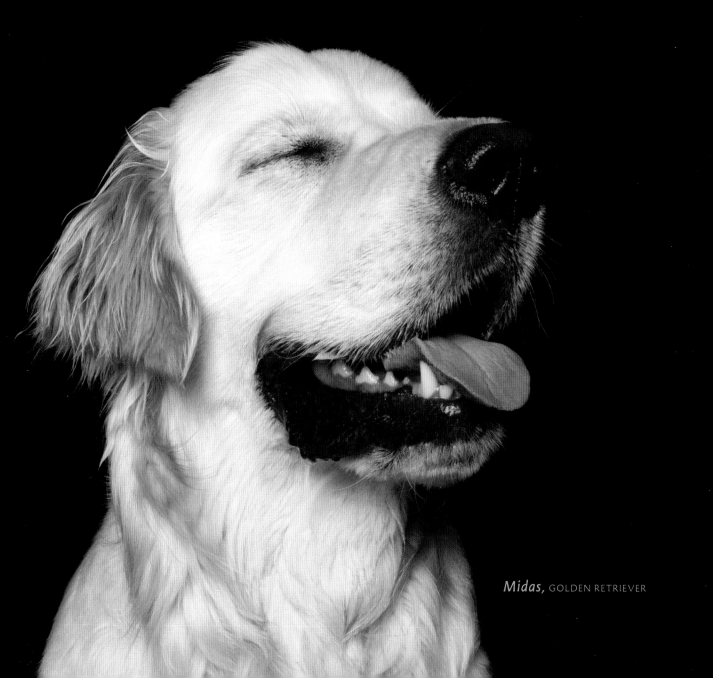

Midas, GOLDEN RETRIEVER

Dexter, BELGIAN SHEPHERD

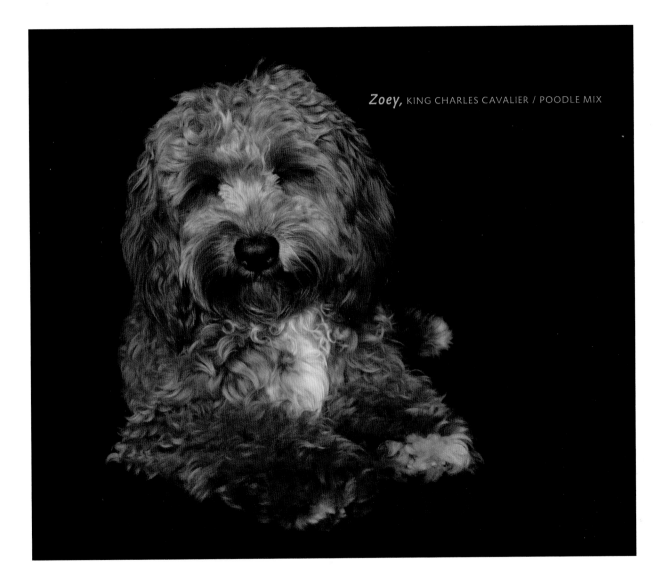

Zoey, KING CHARLES CAVALIER / POODLE MIX

THE DOGS WITH
EYES WIDE OPEN

Abbey

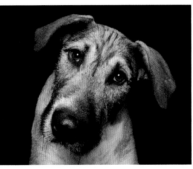

Abbie

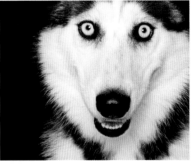

Andromache

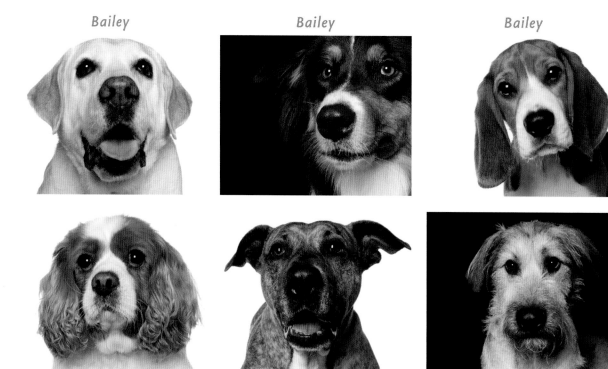

Bailey

Bailey

Bailey

Barney

Bella

Ben

Bo

Boo

Bosco

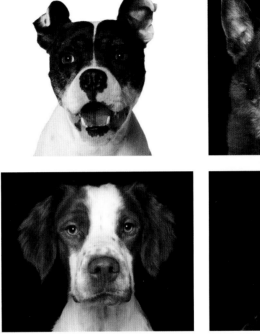

Bubba

Butch

Casey-Jane

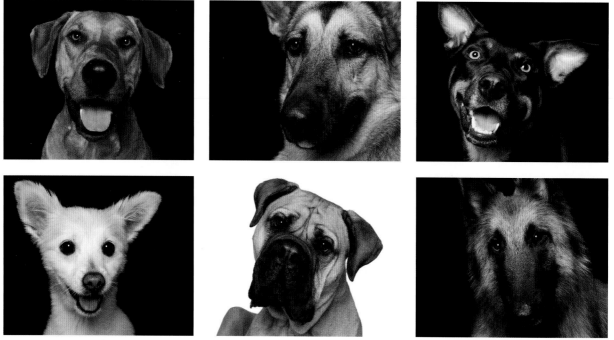

Daisy

Dayzee

Dexter

Dolly

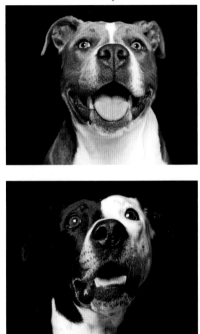

Donnie

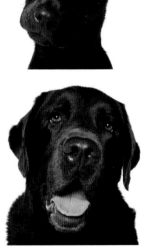

Dozer

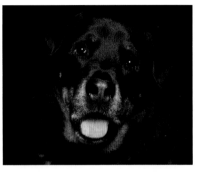

Dozer

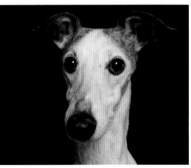

Dug

Effi

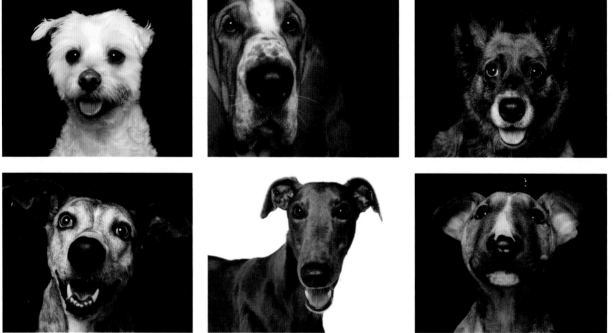

George Gordon Gracie

Grover Hades Hairy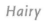

Harley Harrison Harry

Hunter Indy Jeffrey

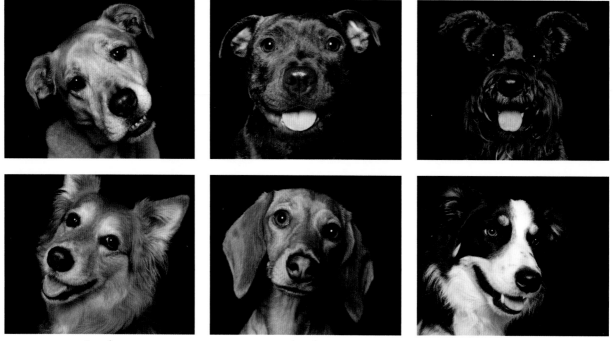

Jessie Jessie Jet

Kato Kelcie Koda

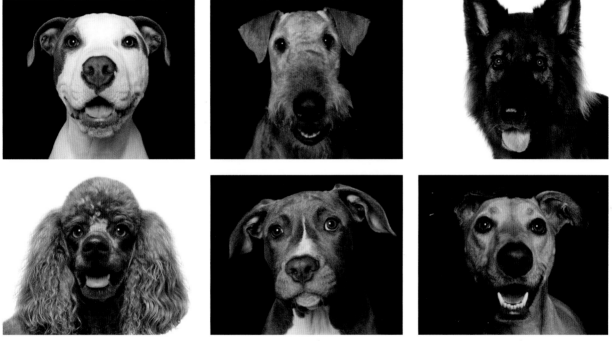

Kono Levi Lexie

Lexie

Lily

Major

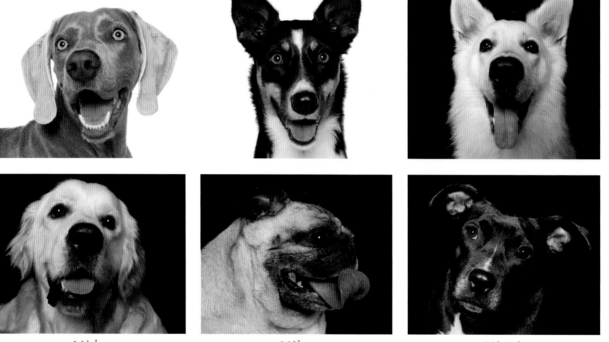

Midas

Miley

Minnie

Mollie Moo

Mr. Scruffy

Muska

Ned

Ollie

Peaches

Pepperoni

Pip

Pixel

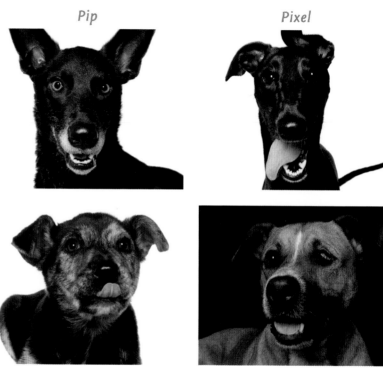

Pluto

Polly

Sam

Sharon 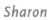 Sidney Simon

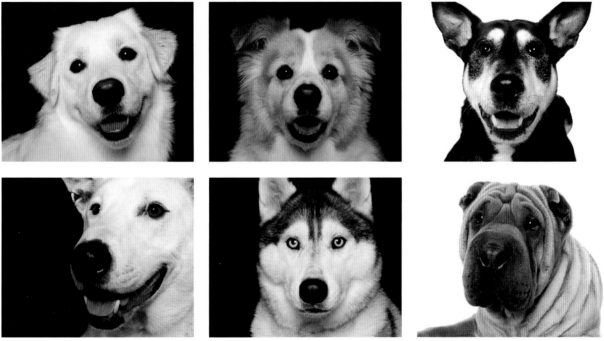

Staiton Storm Suzi

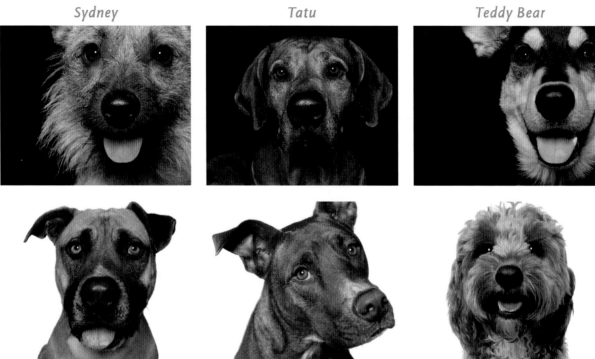

Sydney Tatu Teddy Bear

Woody Zac Zoey

Acknowledgments

First, I would like to express my gratitude to the wonderful people who visit my studio for portrait photographs of their beloved dogs. You can only capture a Zen Dog if you are photographing an authentically relaxed and happy dog. Every dog in this book was very much loved and adored by their humans and living the best type of life a dog can.

To the Zen Dogs themselves, thank you for "giving" me these sweet images. They make people laugh and smile and are a true gift from you to us.

From HarperOne, I would like to thank my kind and patient editor, Julia Pastore, for sharing your *Zen Dogs* vision with me and for your guidance in crafting this book. Your enthusiasm for *Zen Dogs* from start to finish has been infectious, and I greatly appreciate your dedication to making it happen. Thanks also to the entire HarperCollins team for supporting *Zen Dogs* and to Terry McGrath for the beautiful visual layout and design. I'm proud to be a part of the HarperCollins family.

Thanks to Kate Bratskier, Damon Scheleur, and Lindsay Holmes from The Huffington Post for sharing the Zen Dogs images online and creating a viral sensation. Their kind invitation to write about my work led to the very book you are reading now, and for that I am eternally grateful.

To my valued sponsors, Tamron, Elinchrom, Spider Holster, and Team Digital, thank you for providing me with the tools of the trade and equipment fast enough to capture a split-second Zen Dog blink.

I would like to thank my dear friend and advisor Andrea McNamara for her friendship and direction and for always being on the other end of the line. And to the other half of Houndstooth Studio, Debora Brown, for her unwavering support and keen perusal of my written work—and for always letting me know where the apostrophes go.

Lastly, to my closest furry companions, Pip, Pixel, and Macy; to my new acquaintance, Kingston, from afar; and to all of my other dog friends, thank you for your inspiring daily antics and unconditional love, joy, and . . . Zen.

About Alex Cearns

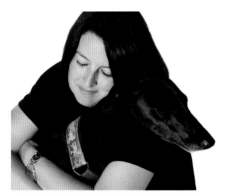

Alex Cearns is Australia's leading professional pet and wildlife photographer and the creative director of Houndstooth Studio. A philanthropist, author, educator, adventurer, and animal advocate with more than sixty awards and accolades to her name since 2008, she specializes in crafting exquisite animal portraits that intrinsically capture the joy people find in animals. Cearns works tirelessly to make a difference in the lives of rescued animals and provides pro bono photographic services, fundraising projects, and sponsorship to around fifty local, national, and international animal charities, shelters, and sanctuaries. Her photography and philanthropic efforts have been featured in print, broadcast, and digital media worldwide, including The Huffington Post, Bored Panda, *Russian Geographic, Woman's Day,* the *Daily Mail,* BBC Worldwide, the *Daily Telegraph, Photo Review Australia, Wildlife Australia, Dogs Today* magazine, and *Dogs Life* magazine, and in an Australia Post national stamp release. Cearns is the global ambassador for Tamron's Super Performance lens series and an ambassador for Spider Holster. She was also selected by global tour company World Expeditions to be their first professional female wildlife photography tour leader. She lives in Australia with her partner, two rescue dogs, and rescue cat.